FOUNDATIONS IN SPIRITUAL DIRECTION

SHARING THE SACRED ACROSS TRADITIONS

BEVERLY LANZETTA

With illustrations by Nicholas Roerich and Beverly Lanzetta

Book design by Nelson Kane

BLUE SAPPHIRE BOOKS

SEBASTOPOL

Blue Sapphire Books website http://bluesapphirebooks.com

Cover and interior design: Nelson Kane

Publisher's Cataloging-In-Publication Data
(Prepared by The Donohue Group, Inc.)

Names: Lanzetta, Beverly, author, illustrator. | Roerich, Nicholas, 1874-1947, illustrator. | Kane, Nelson, designer.
Title: Foundations in spiritual direction : sharing the sacred across traditions / by Beverly Lanzetta ; with illustrations by Nicholas Roerich and Beverly Lanzetta ; book design by Nelson Kane.
Description: Sebastopol, CA : Blue Sapphire Books, [2019] | Series: The monk within series | Includes bibliographical references.
Identifiers: ISBN 9781732343818 | ISBN 9781732343825 (ebook)
Subjects: LCSH: Spiritual direction. | Spiritual life. | Religious art. | Soul. | Interfaith worship.
Classification: LCC BL624 .L362 2019 (print) | LCC BL624 (ebook) | DDC 204--dc23

Printed in the United States of America

contents

There are many fine books on spiritual direction and soul guidance, and some very good ones as well on spiritual direction across traditions. In the midst of these riches, I add my reflections on the value of spiritual direction in contemporary life. A spiritual guide for over forty years and founder of an interfaith spiritual direction program, it has been my privilege to experience first-hand the immense changes that take place when two souls are receptive to honest communication.

Gentleness of spirit is the way souls listen and share, heart to heart. In compiling *Foundations in Spiritual Direction*, I wanted to visually repeat the process and atmosphere that occurs when deep listening and respectful sharing take place. Initially, I created an online course with these materials and had the advantage of experimenting with art images and colored fonts. My joy in the result, and the response of students, convinced me that the combination of spiritual insight and artistic expression was vitally important.

When I approached my dear friend and graphic artist, Nelson Kane, about transplanting *Foundations in Spiritual Direction* from an online course to print and digital forms, he enthusiastically embraced the project. His re-working of the original text, and brilliant use of design, lends an exceptional feeling of warmth and grace to the pages. Through usage of devotional art, we were able to create an atmosphere of color, line, and balance that hopefully encourages a different, more holistic relationship between reader and author that mirrors, in a modern way, the sharing of souls.

Drawing from the wisdom of diverse traditions of spiritual guidance, *Foundations in Spiritual Direction* offers a clear and spiritually meaningful introduction to the history, theory, and practice of this ancient art.

Beverly Lanzetta

Beverly Lanzetta, Ph.D.

To learn more about Beverly Lanzetta, and to see a full listing of her books and art, please go to: beverlylanzetta.net

introduction to the book

how to use this book

Foundations in Spiritual Direction offers an opportunity to study with a contemporary spiritual writer and teacher. The purpose of the journey is to enter into the inner wisdom shared in the pages that follow. You will not only gain conceptual understanding, but also will begin to live and practice what you learn.

In order to receive the full benefit of the spiritual learning in this book, it might be helpful to set aside a special time for the purpose of study. It is often easier to commit to a spiritual practice if it is done regularly during the same period each day. For many people, spiritual attentiveness requires quiet and stillness, and thus early mornings or late evenings work best. Some find they are able to better concentrate in coffee shops, airplanes, libraries, and other social settings. The important thing is to find a time that works best for you.

Each chapter is designed to be read meditatively, in the time-honored manner of sacred reading. By reading slowly and with intention, the words will enter more deeply into your mind and heart. You will begin to see connections between the subject matter of the chapter and your inner knowing. Since *Foundations in Spiritual Direction* is experiential, the more time you take to reflect on and write about what you have learned, the more integrated the practice will become in your life.

To facilitate this process, *Foundations in Spiritual Direction* includes meditative practices drawn from the world's religions, suggestions for further study and research, and informative definitions of spiritual terminology. To achieve maximum benefit from the book, you are encouraged to try each of the meditation and prayer practices, and investigate further the new concepts and insights presented. With the incredible resources available online and through community and academic libraries, you no doubt will be enriched by further study.

keeping a journal

Following the subsection of each chapter is a page of journal questions. These are designed to facilitate the awakening of your inner wisdom through the process of writing. Perhaps the most important benefit of journaling is to write freely and openly from your heart, without worrying about grammar or spelling. The writing is for you to gain insight into your life and thoughts. Be honest with yourself and try not to judge or limit what you write. Simply write.

Keeping a journal is a form of meditation. Some people like to begin and end the writing process with a prayer or short period of silence. Others enjoy plunging in, writing without stopping and allowing the movement of the pen to guide their untapped thoughts. To encourage spontaneity, you might benefit from having a notebook dedicated to questions and reflections raised in this study. It can be carried with you, and be available to record your experiences and insights. By whatever method, the process of journal writing will drink from the great well of silence within you. Allow it to flow!

Writing in a journal can be done privately, with a friend, or in a group setting. Journaling, as an activity of self-reflection, also can be verbal—the sharing with others personal insight, critical thought, and related knowledge. Perhaps most important is to allow yourself to tap into the depth of knowing within. In this way, the activity of journal writing and group sharing can lead to further integration and self-mastery.

Foundations in Spiritual Direction

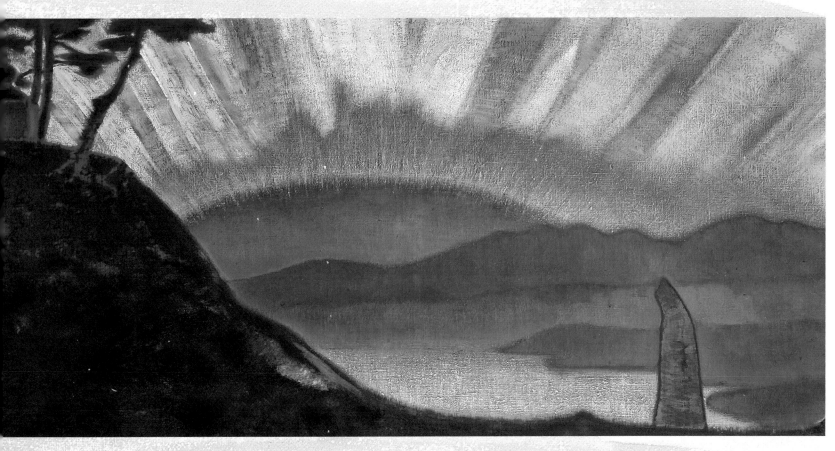

Individuals seek out spiritual directors to assist in their special desire to grow in the spirit and to attain wholeness, freedom, and divine union.

beginnings

Throughout history the essential ministry to which spiritual direction refers—guiding others in their spiritual life—has been practiced by religious figures in all the world's religions, among them the *roshi, guru, rebbe, lama, shaykh,* and *shaman.* The specific term "spiritual direction" and its historical development can be traced to Christian roots, and for much of the last centuries it has been the exclusive preserve of Christian—especially Catholic and Orthodox—denominations. Once the province of religious authorities, today spiritual direction has broken out of the confines of religious denominations to become a practice of spiritual sharing and soul guidance open to individuals from diverse religious and non-religious backgrounds. Recognizing that "the spirit" is intrinsic to all people and all human endeavors, the contemporary ministry of spiritual direction is offered in traditional religious settings as well as in hospitals, hospices, schools, medical practices, corporations, and other social environments.

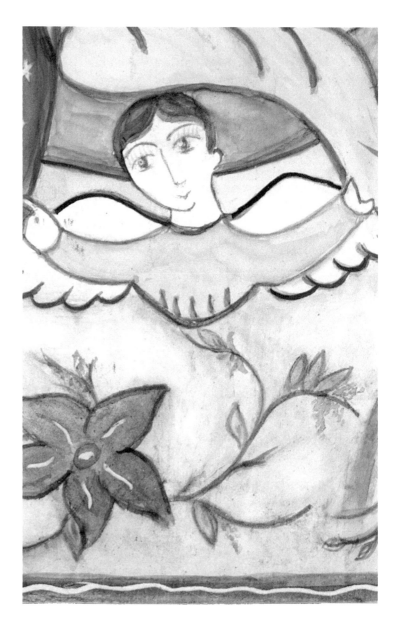

Spiritual Direction is concerned with helping a person with his or her relationship with God, Ultimate Reality, or the Holy, however named or defined. In all traditions, spiritual guidance is the tracking of the subtle stirring of the spirit within the person, in order to discover and discern one's original, undivided nature. The intention of spiritual direction is to foster communion between the person and the Divine through a process of attentive awareness to the movement of the spirit in the inner life of the person. The main role of the spiritual director is to listen for this movement within the person, and to gently guide another to an awareness of the spiritual signs and deeper levels of transformation that lead to a new life interpretation and a new understanding of the self in the world.

Individuals seek out spiritual directors to assist in their special desire to grow in the spirit and to attain wholeness, freedom, and divine union. The primary purpose of spiritual direction or spiritual guidance is to aid a person in achieving awareness or in enlightening their souls: to find the Spirit, discover Buddha within, experience *samadhi*, or unite in mystical union with God. It is this quest for authenticity and love, this quest to know one's true self and to know the Divine, that is the purpose of spiritual direction. Although

people employ spiritual direction for all types of interior issues and for soul healing, it always aims at the mystical unity and purity of heart that constitutes personal holiness. It involves the deep core of the person.

The primary focus of spiritual direction is on religious experience, not ideas, and how this experience touches the most profound level of the person. It is concerned with the inner life, that dimension of existence that deals with the heart, and the deep feeling states that arise from the closeness of the person to his or her divine source. It investigates an interior landscape, with its own rules and properties, ways of knowing, and ways of seeing. Spiritual direction addresses this process of interiorization to awaken the seeker to consciousness of the path along which he or she is being led by the Divine within. The work of the director is not to give spiritual direction but, as St. John of the Cross says, "to prepare the soul. It is God's work to direct its way to spiritual blessings by ways neither you nor the soul understand."

The primary focus of spiritual direction is on religious experience, not ideas.

The whole purpose of spiritual direction is to penetrate beneath the surface of a person's life, to get behind the façade of conventional gestures and attitudes which one presents to the world, and to bring out one's inner spiritual freedom, one's inmost truth, which is what we [Christians] call the likeness of Christ in one's soul. This is an entirely supernatural (spiritual) thing, for the work of rescuing the inner person from automatism belongs first of all to the Holy Spirit.

Thomas Merton

In history, spirituality has been the champion of unity and kinship among peoples, and the binding nourishment and wisdom of diverse civilizations. Yet there is no universally acceptable definition of spirituality. In many cultures the spirit is so embedded in daily activities that there is no comparable word, "spirituality," to distinguish it from life itself. Nonetheless, each language and culture has it own "spirit" words. In the Abrahamic traditions, the Hebrew *ruah*, and the related Arabic *ruh*, convey a similar sense of the invisible and intangible movements of breath, air, and wind as the Latin *spiritus* or *pneuma* in Greek.

The Latin word *spiritualitas* (spirituality) seems to have been first used by St. Jerome in an early fifth-century letter. But it is not until the sixteenth century onward that the word "spirituality" is found in the English language. A rarely used word until modernity, during the Medieval period its meaning was closely tied to Christian practice and spirituality was often depicted as a higher, otherworldly realm as opposed to the physical.

In the Jewish traditions, seeking the face of God, living in the Divine Presence, and conducting one's life in accordance with God's holy intention comes close to a definition of spirituality faithful to its Semitic roots.

what is spiritual?

In Islam, spirituality is a word of Arabic origin with two distinct connotations. In the Qur'an the Spirit (*ruh*) emerges from the command of God; it also has a second meaning, of inwardness, pertaining to a higher level of Divine Reality, and to the presence of the *barakah*, the grace that flows through the universe.

Specific spirit words, each within their own context, exist as well in Japanese, Chinese, African, and Indigenous tribal religions. In Buddhism, the closest equivalent for the term spirituality is perhaps the Sanskrit *bhavana*, or "cultivation," which signifies not merely an interior reality or an escape from ordinary existence. It does not presuppose any dualism between the spiritual realm and that of the senses or between a sacred dimension and the profane world. Rather, Walpola Rahula clarifies:

> *It aims at cleansing the mind of impurities and disturbances, such as lustful desires, hatred, ill-will, indolence, worries and restlessness, skeptical doubts, and cultivating such qualities as concentration, awareness, intelligence, will, energy, the analytical faculty, confidence, joy, tranquility, leading finally to the attainment of the highest wisdom which sees the nature of things as they are, and realizes the ultimate truth, nirvana.*

"The locus where there is absent a sense of 'I' and 'mine' is the locus of spirit..."

Similarly, the religions of the Indian subcontinent have a rich heritage of words, such as *Brahman* (Eternal Absolute), *atman* (immortal self), *citta* (conscious mind), and *prana* (breath), to refer to both the Divine Spirit and the human spirit in its various guises

and manifestations. Focusing on a person's inner relationship to one's ultimate source, Hinduism places particular emphasis on the interdependence and nondualism of spirit and matter. In Hindu practice, living a spiritually focused life requires a letting go of ego-identity. As Krishna Sivaraman clarifies: "The locus where there is absent a sense of 'I' and 'mine' is the locus of spirit."

In each of these varied cultures and languages, we can think of spirituality as the all-pervading divine energy and seamless web of oneness intimate to life itself. Creation is not alone, separate from its source, but deeply and mysteriously imbued with spirit in every aspect of mind, soul, and matter. Thus, spirituality relates to the core or deepest center of the person open to the transcendent. It is here that the person experiences ultimate reality.

Today, spirituality is used in secular and religious contexts, and is applied across and within disciplines, as well as in medicine and other healing arts. In a sense, spirituality has become a kind of universal code word to indicate the human search for meaning and purpose in life, and as a quest for transcendent truth. Although spirituality is historically related to religious

traditions, it is also found in secular settings, and in all human societies through an individual experience of the divine, a connection to nature, and/or through religious practice.

From these diverse definitions, we can see that the word "spiritual" in spiritual direction does not mean just the guidance of one's spiritual activities, as if spirituality were but one small part or department of one's life. Rather, spiritual direction is concerned with the whole person, for the spiritual life is not just the

life of the mind, affections, or prayer—it is the life of the whole person. The spiritual person is one whose whole life in all its dimensions and activities has been drawn into the action of the spirit. Moreover, spiritual direction is concerned with the whole person not simply as an individual human being but as integrally connected to the web of relations, as a person seeking to experience the divine presence within all of life.

...the spiritual life is not just the life of the mind, or of the affections, or of the heights of prayer, it is the life of the whole person.

what is spiritual?

What does the word "spirituality" mean to you?

In what way would you distinguish spirituality from religion?

Is there anything about how the term "spirituality" is used today in popular culture that affirms, conflicts with, or disturbs your own understanding?

what is direction?

Travelers setting out from Chicago to Santa Fe need a map to guide them in the proper direction and choice of roads as they navigate the languid valleys, rushing waters, and steep mountain passes that separate the two cities. In a similar way, people embarking on a spiritual journey benefit from the wisdom of a seasoned guide who can help them to understand the point of their departure and to learn how to identify and track the often unmarked and unnamed inner landscape they will cross. Use of the word "direction" in spiritual direction conveys this sense of staying on course—of helping another person to maintain a spiritual focus through the subtle and sometimes bewildering twists and turns of life. Thus, in spiritual direction the word "direction" is not meant to imply obedience to or command by another person, group, or institution. Rather, it refers to a common lived experience: spiritual companionship and guidance are necessary in order to stay on one's path to freedom and to discover one's true self or God. It is listening with another person to the inner movement of the Divine within us, leading us to new understanding, sanctity, and love.

The task of spiritual directors is not to instruct, preach, or give moral guidance. Their task is to help people

experience and listen to the action of the Spirit and respond to it. Fostering discovery rather than teaching doctrine is their purpose. For this reason, people today speak of spiritual guidance, spiritual friendship, soul mentoring, and other terms to signify that no forceful or dogmatic direction is given. Rather, spiritual direction involves a subtle level of consciousness, in which we are guided from within our deepest natures to the transcendent meaning of our lives.

Understanding that spiritual direction is not about moral instruction or demonstration of truth must be stressed. The reasons for this are:

♦ The almost universal and deeply entrenched tendency of ministering people to want to inculcate truth, to teach and instruct.

♦ The tendency of spiritual directors to believe they must enforce or "do" spiritual direction, rather than being with the person.

♦ The desire on the part of spiritual helpers and directors to effect changes and see outcomes coincident with their own beliefs or goals.

The meaning of the word direction or guidance in spiritual direction is to emphasize, verify, and encourage what is truly spiritual in the person. A spiritual director is, then, one who helps others to recognize and to follow the inspiration of grace in their lives in order to arrive at the end to which the Divine is leading them.

Spiritual companion-ship and guidance are necessary in order to stay on one path to freedom and to discovery of the true self or God.

Models of Spiritual Direction

In its purest sense, the spiritual direction relationship was seen as a window onto a divine-human communication shared between two people.

history of spiritual direction

From the earliest accounts of human religiosity, spiritual guidance has been closely tied to the quest for ultimate meaning intrinsic to all religious traditions. The shaman, Delphi oracle, and Rig Vedic seer are among the earliest religious figures depicted in literature. Similarly, the Vaisnaya *guru*, Taoist sage, Sufi *shaykh*, Tibetan *lama*, and prophets of the Hebrew Bible functioned as conduits between the realm of the spirits and earthly life. When a person needed assistance on the journey of faith, he or she sought out the wisdom of a religious authority sanctioned by the community. In some form throughout human history, there always has been a dialogue between persons concerning the mystery of guiding the inner life.

In the Christian tradition, spiritual direction can be traced to the desert *abbas* and *ammas* (fathers and mothers) of the early fourth century. These were people who left Alexandria, Antioch, and other cities of Asia Minor to travel into the desert regions to find God and to live in peace, solitude, and wisdom. Their primary desire was to live apart from the materialism and institutional oppression of their day in order to focus their whole life on devotion to God.

In the desert fathers and mothers, spiritual guides replaced the bishop or presbyter as representative of Christ. The greatest abbots in the Egyptian and Syrian deserts were generally not ordained clergy or vowed

religious, and there was nothing hierarchical about their function. It was purely and simply a spiritual gift. Guidance was sanctioned solely on the basis of their own holy lives.

The desert monastics were seekers of the true self, practicing simplicity, honesty, and purity of heart. Their primary commitment was to mystical union and many pilgrims sought out these holy souls for spiritual advice on the path. The sayings of the desert fathers and mothers remain an eloquent witness to the simplicity and depth of this spiritual practice. The impact of their words resided not so much in their content as in the inward action of the spirit in the soul of the

hearer. The spiritual longing and desire to understand the deeper meaning of life was generated by stirrings of love. Direction was understood as God's answer to a need created in the soul to confront one's inner trials, longings, and self-recriminations, communicated through the charismatic message of the abbas and ammas.

Disciples often traveled for miles through the wilderness just to hear a brief word of advice or a word of salvation. Pilgrims came to sit with an elder who would listen to the yearnings of their souls and offer guidance on the path. In the early days, a spiritual director was one who had been called to seek God by an unusual and perilous road. These were spiritual masters who begot the perfect life in the soul of disciples by their instructions first of all, but also by their prayer, sanctity, and example. To the pilgrims, they represented a kind of sacrament of Jesus' presence in the ecclesiastical community.

The dialogue or encounter between teacher (director) and pilgrim (directee) was considered holy, in the sense that true guidance was the work of the Holy Spirit and

Directors were people who had struggled, learned, and lived through their own transforma-tion.

FOUNDATIONS IN SPIRITUAL DIRECTION

not of the human mind or intellect. Specifically, the directee was to speak from the heart, soul to soul; and the director was to listen with a deep, inner stillness that allowed for the reception of insight that could not be found through rational knowledge alone. In its purest sense, the spiritual direction relationship was seen as a window onto a divine-human communication shared between two people.

Directors were people who had struggled, learned, and lived through their own transformation. They were wise in the ways of the spirit. Through their spiritual struggles and yearning to know God directly, they experienced both the heights and the depths of the inner life. They knew their own weaknesses, sins, and temptations. They had battled the fear, arrogance, despair, abandonment, futility, and greed that grip the human person. Yet, they also knew of religious experience, when God comes to one directly and fills the self with divine presence. Theirs was not just a material knowing, but a knowing of the mysteries of the spiritual life—how one lives and follows a contemplative path. For them, the mystery was apparent: they not only experienced it, they understood its variations and had, from experience,

Charismatic

The word charismatic is derived from the Greek word *charis* (meaning a grace or a gift) which is the term used in the Christian Bible to describe a wide range of supernatural experiences (especially in 1 Corinthians 12–14). It also refers to the special quality that confers on the person holding it an unusual ability for leadership or worthiness of veneration. Similarly, the word charism means divine gift, or gift of the Holy Spirit in the Christian traditions.

learned its measure and its types. Far from being obscure and indistinct, the inner life was teaming with a precision and an intellectual brilliance that was unmatched by any of the world's knowledge. It was this wisdom that allowed them to interpret human situations from the perspective of awe. Having surrendered to this vast and untracked wilderness, they became cartographers, mapping an interior landscape in which they offered solace for other souls.

Do people seek you out to share their spiritual needs and stories?

What are the attractive qualities of the desert fathers and mothers?

How or in what way would you appropriate the wisdom and commitment of the desert monastics into your own life?

history of spiritual direction

The fathers of old went into the desert, and when they were made whole, they became physicians, and returning again they made others whole; therefore it is said, *Physician, heal thyself.*
—St. Anthony of Egypt

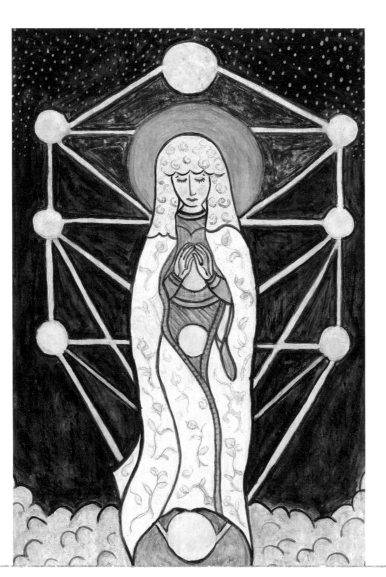

Since spiritual direction always involves an effort to heal the person, medical terminology was often utilized in the traditional literature. This usage was already rooted in Greek philosophy, where healing was seen to occur through the sage, who guided the person into the inner life. Thus, Socrates saw himself as an *iatros tes psyches*, or soul healer. In the writings of the desert fathers, the spiritual director was described as a "spiritual physician," *iatros pneumatikos* in Greek. The focus of the spiritual physician was to heal the person and to assist the pilgrim's growth in holiness and communion with God. The spiritual director or spiritual physician listened for and guided the directee to become aware of three different movements of the spirit: within one's mind and heart; between oneself and God; and between oneself and his or her fellows.

The dialogue between master and pilgrim could include elements both related to an individual's ongoing prayer life or practice and to the daily struggle for wholeness and healing, including one's thoughts and actions, psychological and emotional movements, and theological and spiritual understanding. It was a life interpretation of one's inner and outer experiences that the spiritual physician always aimed at awakening in believers regarding their motivations and predicaments. History reveals that direction was sometimes gentle, radical, or blunt; however imparted, it never avoided or denied the real, operative factors of an individual's circumstances, whether they were evaluated as positive or negative, constructive or destructive. In short, were truth denied, no healing could occur.

The greatest healing was possible when individuals opened their hearts in the presence of a holy one who listened with the wisdom of the Spirit to the failings and grandeurs of the human heart. The deepest sufferings and greatest joys, as well as the interior

DEFINITIONS

Metanoia

From the Greek, meaning to turn around, to change one's heart, to repent.

To repent is to look, not downward at my own shortcomings, but upward to God's love; not backward with self-reproach, but forward with trustfulness. It is to see, not what I have failed to be, but what by the grace of God I can yet become.

Kallistos Ware, *The Inner Kingdom* (Crestwood, NY: St. Vladimir Seminary, 2000), 45.

Teshuva

A Hebrew word, meaning return. If a person violates one of God commandments (*mitzvos*), he or she is required to return to God. *Teshuva* consists of three steps: admitting one's sins, feeling regret that one sinned, and making a commitment not to repeat the sin.

Tawbah

The Arabic word *Tawbah* means "to return" and is used to convey two distinct thoughts: humans turn to God for mercy, and God turns to humans in mercy. It also implies the existence of a state of right conduct, and the commitment to renunciation of the sin; firm intention to not return to the sin again; regret over having committed a sin; and, if the sin is against the rights of another human being, then one must also compensate for it.

The greatest healing was possible when individuals opened their hearts in the presence of a holy one who listened with the wisdom of the Spirit.

motivations of the soul, were brought to the spiritual physicians. They guided others to a change of heart, to repent (*metanoia* in Greek), and to follow a new path toward love of God. Yet this metanoia was not born of despondency and despair, or punishment and self-denial, but of expectant hope. It was the realization that true awareness of one's failings springs from the inner activity of the spirit, giving an individual the courage to change life directions and focus one's heart on the quest for meaning and love. In this way, the guidance of the abba or amma assisted the seeker after truth to understand that the spirit within was the source of moral courage and self-determination.

The deep challenge of the inner life and a key factor that distinguished spiritual elders more advanced on the path from beginners is this: the ability to see the core of another's soul with love and compassion; to see truth without judgment, condemnation, desire to inflict suffering, cruelty, or piousness. But to see another person clearly, dispassionately, and fully through a heart of love.

Does the image of the spiritual physician find resonance in your own experience?

What spiritual wound or suffering have you shared with another person?

Is there any spiritual wound you would be afraid to share? Why or why not?

Reflect on the importance of the spiritual director having a fully open and loving heart that is without judgment or condemnation. Do you feel you are able to be compassionate in this way?

spiritual physician

models of spiritual direction

There are probably as many different types of spiritual direction relationships as there are people. In considering the history of the world's religions, however, we find certain distinctive religious figures and models of spiritual dialogue and guidance. Among them are:

Guru

In the devotional spiritualities of the Indian subcontinent, the guru (from the Sanskrit: spiritual teacher or guide) is a central figure in religious and cultural settings. She or he is looked upon as a holy person or even an incarnate god or goddess with the wisdom and the power to not only guide a person in the spiritual life but to effect interior transformation as well. For many of these cultures, spiritual guidance occurs within the complex rituals that sustain faith, and the stages of life coincident with one's age and station. The relationship between guru and disciple is an unequal one, where the person seeking guidance is thought to be in the presence of one elevated in spiritual wisdom and personal holiness.

Lama or Roshi

The many branches of Buddhism have given rise to a variety of religious functions and titles. Two of the most well-known are the Tibetan Lama and the Zen Roshi. While born from distinctive forms of Mahayana Buddhism, these religious authorities function in similar ways as spiritual masters who have achieved a high level of spiritual wisdom and thus are endowed with the ability to pass on the original enlightenment experience of Gautama Buddha. The relationship could not be called one of guidance in the traditional Western sense of spiritual direction, which proceeds by dialogue and mutual sharing. Rather, the purpose of an audience with one's teacher or elder (*thera* in Pali) resides with the power of spiritual transmission attributed to the lama or roshi to effect in the disciple the liberated state of consciousness central to Buddhist philosophy and practice.

Priest or Elder

The word "priest" comes from the Greek *presbyteros*, which is generally translated as elder. It is an ancient term for designating the person who may enter the presence of God. The historical function of the priest is primarily sacramental where, through special prayers and ritual actions, the priest takes an object from the profane world and makes it holy. The priest or elder serves as an intermediary between the people and God, and is anointed by his or her spiritual community to absolve sins, hear confessions, and function as a spiritual father or mother.

Rebbe

Spiritual guidance is reflected in diverse ways in Jewish history. Early examples of spiritual companionship are depicted between Naomi and her daughter-in-law Ruth in the book of Ruth; and include the counsel imparted by the *zechenim* or *hachamin*—wise elders—during the same period (approximately 1050–30 BCE). Much later, during the eighteenth century, the Hassidic Movement attracted many followers who sought spiritual guidance from their rebbe (rabbi) in a session known as the *yehidut*, or interview. The function of the rebbe was to serve as a *moreh derekh*, or spiritual guide, who represented a living example of divine love capable of alleviating suffering and leading the disciple to God.

Sage

The sage is a religious type found in the philosophical traditions of China and Greece. In China, the sage became the ideal personality of the Confucian tradition who modeled the potential of cosmic relatedness within the human order by cultivating sincerity (*ch'eng*). For the sage, the most ordinary human actions are the means for transforming and nourishing all beings, as one's natural sincerity becomes attuned to the moral order in the universe. The sage cultivates a special mode of sympathetic relationship with the world, and helps to arouse in others a self-reflection that reveals their own deepest humanity.

Spiritual direction is not primarily about problem-solving but is concerned with helping individuals with their relationship to their divine source.

Shaman

The shaman is the central religious figure of indigenous cultures around the world. He or she functions as an intermediary between the earth world and the realm of the Spirit, mediating the relationship with the spirits and serving as a conduit for healing. The shaman in a special way imbibes or absorbs the pains and wounds of others in order to effect a transformative healing in the person and in the community as a whole. The shamanic healer is one who takes on the burdens of those who come for guidance and who has traveled through the often-lonely path of inner death and rebirth in order to experience the emptiness that is the source of the All.

Shaykh

In Sufism the central religious figure is the Shaykh, who guides the disciple in *tariqat*, the inner path of the heart. As spiritual guide, the Shaykh is both a messenger and reflection of the Divine, and it is through the bond between disciple and teacher that the mystical opening of the heart is said to occur. The deepening of the spiritual life is understood in Sufism to be expressed in the affirmation of God's absolute all-encompassing existence which longs to be known, and the reality of the human being as a secret treasure of God.

Soul Friend or Companion

This is the model most often taught and used today, in which persons serve as spiritual companions and soul friends on the journey. While the modern practice of spiritual direction involves openness of heart and intuitive listening, spiritual directors today are trained to be peer spiritual guides and soul companions or friends on the journey rather than gurus, masters, or

healers. Although the relationship between directee and director can be friendly, it is not what we typically think of as friendship. The person in his or her role as spiritual director is trained to maintain proper and helpful boundaries that support the spiritual direction process.

In each of these varied models, it is important to keep in mind that spiritual direction is not psychotherapy. The director may use or be trained to recognize whatever knowledge can be gained from the field of psychology, but this knowledge must not be imposed on the spiritual relationship or be looked upon as sufficient in itself. It must be kept in mind that spiritual direction is not primarily about problem-solving but is concerned with helping individuals with their relationship to their divine source, however defined or named.

models of spiritual direction

Which model of spiritual direction resonates with you?

What characteristics would you want to find in a spiritual director?

Reflect on the kind of spiritual direction relationship you might have with a person from a faith tradition different than your own.

Fostering Contemplation

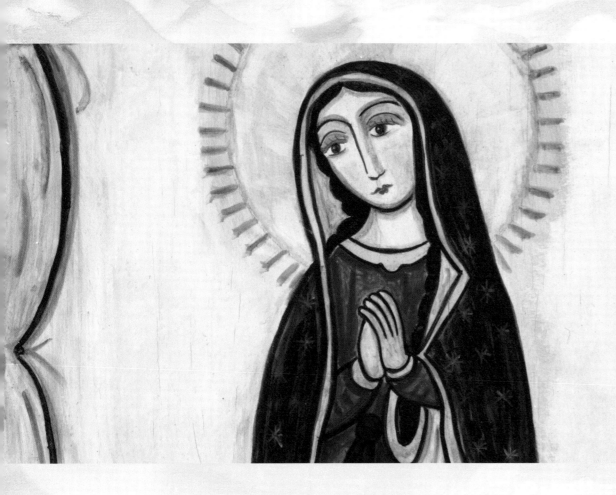

To maintain the interior focus and the strength of love necessary to listen with one's whole being, the spiritual director must be a person committed to the practice of prayer and meditation...

Like the desert ammas and abbas, spiritual directors are called by the Divine to be spiritual persons in their own right as well as spiritual directors. As a spiritual director, the person is passing on an ancient lineage that has taken place from heart to heart and soul to soul. Sometimes written, spiritual direction is primarily an oral tradition in which the workings of the divine mystery are witnessed in the inner life of the person.

This gift of being able to listen to and read the signs of the spirit is the subject of spiritual direction. That is, it is the movement of the Divine or Way in us, and how we detect the subtle manner in which the person is being drawn toward personal holiness or to achieve liberation of mind. Like a river, the spirit moves according to its time and in its own way. It cannot be imposed; it cannot be forced. It is the practice of a gift, to be attentive to the presence that animates our lives and gives meaning to our existence, in order to find the true self. The way is deeper than silence and more subtle than words and, thus, requires the stillness of a contemplative heart.

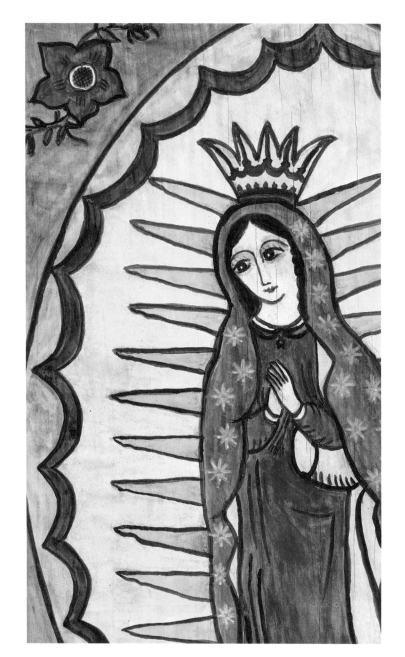

Three Gifts of the Spiritual Guide in Orthodox Christianity

Insight and discernment (*diakrisis*)

♦ The ability to perceive intuitively the secrets of another heart, to understand the hidden depths of which the other does not speak and is usually unaware. This power is spiritual not psychic, that is, it is not simply a clairvoyance or extrasensory perception, but the fruit of grace.

♦ The ability to use words with power, knowing immediately and specifically what the person before them needs to hear.

♦ By few words, or by silence, he or she is often able to alter the direction of another life.

♦ Gift of insight exercised through the practice of *logismoi*—the disclosure of thoughts and unveiling to one's guide ideas and impulses which may be detrimental in the end.

The ability to love others and to make others' sufferings their own.

♦ "He possessed love and many came to him."
　　　　　　　　—*Sayings of the Desert Fathers.*

♦ Without loving compassion, insight into people's hearts would be destructive and not creative.

♦ Loving others involves suffering with them; taking into one's soul the soul of another, and praying for wholeness and healing.

Power to transform the human environment, both the material and non-material.

♦ Gift of healing is one aspect of this power.

♦ Helps others to perceive the world through God's eyes and as God desires it to be.

♦ Discerns the universal presence of God throughout creation and assists others to discern it as well.

Excerpted from *Kallistos Ware, The Inner Kingdom* (Crestwood, NY: St. Vladimir Seminary Press, 2001), 135–140.

What is the Method of Spiritual Direction?

The most important method of the spiritual director is the deepening of his or her contemplative life. Although today many different techniques are taught, and various strategies for listening are practiced and recorded, the depth of the spiritual director and his or her ability to be a wise guide arise from the cultivation of silence and the motivation of a pure heart. To maintain the interior focus and the strength of love necessary to listen with one's whole being, the spiritual director must be a person committed to the practice of prayer and meditation, and to the stilling of the intellect, silencing of the memory, and suspending of digressive emotions or attractions.

No amount of study, self-discipline, or practice on its own prepares a person to deepen her or his interior life. The main condition necessary for the spiritual director is the sincere and complete desire to pursue one's love of the holy, however defined and understood by each person. When this intention is fully present, then any healthy spiritual practice naturally draws the person into the more profound and subtle aspects of the life of prayer, and to the spiritual attunement that is the hallmark of wise and humble guides.

The most important method of the spiritual director is the deepening of his or her contemplative life.

Reflect on and write about spirituality in your life and its relationship to sensitivity, inner centeredness, deep listening, and other traits of a mature spiritual guide.

spirituality of the director

fostering a contemplative attitude

Spiritual directors maintain a consistent practice of prayer and meditation not only to be effective and receptive listeners, but also to stabilize and deepen their whole being. Many people practice some form of meditation or prayer, such as Centering Prayer, The Amidah, Hesychast Prayer, Vipassana Meditation, Zazen, or Dhikr. The main intention of all of these prayer forms is to deepen one's ground of silence and to open one's inner self to the direct inspiration and movement of the Spirit.

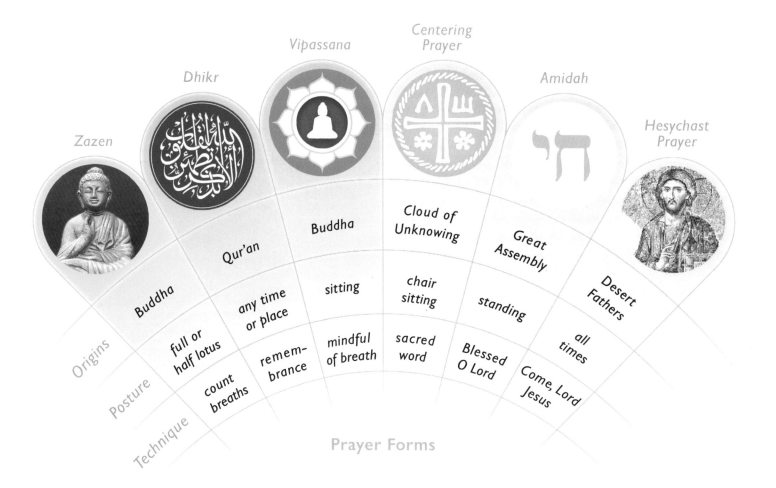

	Zazen	Dhikr	Vipassana	Centering Prayer	Amidah	Hesychast Prayer
Origins	Buddha	Qur'an	Buddha	Cloud of Unknowing	Great Assembly	Desert Fathers
Posture	full or half lotus	any time or place	sitting	chair sitting	standing	all times
Technique	count breaths	remembrance	mindful of breath	sacred word	Blessed O Lord	Come, Lord Jesus

Prayer Forms

Zazen

The practice of Zen meditation, or *zazen*, is considered to be the most direct way to enlightenment. *Zazen*—from the Japanese, *za*, sitting and *zen*, absorption—does not involve focusing the mind on an object or graphic representation, but is intended to free the mind from bondage to any thought-form or vision, however mundane or sublime. In its purest form, *zazen* is the state of contentless wakefulness, from which the practitioner breaks through to a realization of his or her own true Buddha nature. In Zen meditation, practitioners sit for the sake of sitting, letting go of all distractions, experiencing life in the present moment with each breath.

Method

Many different sitting postures are used in Zen meditation, but the most common form is the full lotus position. In this posture, the person is seated on the floor with legs folded across each other, and with the left hand resting on top of the right, palms up and open. The spine is kept straight and the head is kept erect, with the eyes half-closed and the gaze at a 45-degree angle to the body.

The method of Zen meditation involves the counting or awareness of breaths. Thoughts come and go and are allowed to pass away. No lasting attention is paid to thoughts, as all attention is focused on breathing in and out. Beginners are taught to count breaths from one to ten, usually on exhalation, and to continue the sequence over again for the duration of sitting. Another method is to follow the breath, by simply placing attention on your breath as you inhale and exhale.

When your mind wanders (which it inevitably will), return your attention to the breath or to the counting of the breath. Do not be discouraged if your attention wanders, for the natural state of the mind is to produce thoughts. Rather, as you keep focusing your

attention on your breath, your thoughts will naturally become quiet.

Zen teachers suggest that beginners sit for short periods, lasting from 10 to up to 30 minutes. After 25 or 30 minutes of sitting, it is a good idea to change postures or end the session. A walking meditation is an excellent way to take a break between sittings. To begin: walk slowly and deliberately, placing one foot in front of the other. Notice how your feet touch the floor, how your muscles contract and relax as you take each step. If your mind wanders, return your attention to the slow, deliberate movement of "just walking." After a few minutes of meditative walking, it is easier to return to sitting meditation, or to gracefully end the meditation cycle.

Dhikr (pronounced *zikr*)

Dhikr is a form of worship used by Muslims, especially Sufis, in which a name of God or a short religious phrase is repeated over and over again. The Arabic term *dhikr* means remembrance, and the practice is mentioned in the Qur'an: You who believe, remember God with all your memory (33,41).

The chief purpose of *dhikr* is the restoration of wholeness in people. The Sufi masters, therefore, prescribe different medicine to their followers in the form of different kinds of chanting and recitation according to the needs and illnesses being treated.

In its journey to reach the Divine Presence, *dhikr* is the means by which the soul grows in grace. Continuous

prayer plants the seed of remembrance in the heart, until the tree of *dhikr* becomes deeply rooted and bears fruit. Seekers strive to remember their Lord with every breath, as the angels are always in the state of *dhikr*, praising Allah. If the Lord is remembered in every moment, peace and satisfaction will rest in the heart, spirit, and soul will be uplifted, and the seeker will sit in the Divine Presence.

Method

While the Muslim ritual prayer (*salah*) has to be performed at specific times and under certain conditions of purity, *dhikr* can be done at any time or any place. *Dhikr* is usually recited by counting on the fingers or on prayer beads (called *sibhah*) and repeating phrases 33 times each. Among the phrases repeated in Arabic are *laa ilaha illa Ilah*, "there is no god but God"; *subhanu Ilah*, "Oh God Almighty"; *al-hamdu li-llah*, "praise be to God"; *allahu akbar*, "God is greater"; *astaghf iru Ilah*, "I ask for God's forgiveness"; or simply Allah, "God." *Dhikr* can also involve music and spiritual songs.

Vipassana Meditation

Vipassana is a word in the Pali language, one of the ancient languages of India along with Sanskrit. *Vipassana* is translated as "insight meditation" and is also called mindfulness meditation because it is directed toward self-purification by observing the universal truths of impermanence, suffering, and egolessness. It is said to have been taught by the Buddha as a means of attaining truth-realization by direct experience.

The main technique involves becoming extraordinarily aware of ordinary experience by observing the natural breath and concentrating the mind. With a sharpened awareness, one is able to be attentive to the deep universal issues that motivate our lives: pain and pleasure, satisfaction and neediness, self-interest and generosity, and so forth.

With a sharpened awareness, one is able to be attentive to the deep universal issues that motivate our lives

Method

Find a place where you can sit comfortably, undisturbed. Keep your back and head straight, sitting on the floor in a full or half lotus, or in a chair.

Focus your mind's attention on your abdomen, following the rising and falling of your breath. Restrict your attention to what is occurring in the *immediate present moment*. Don't think about the past or future—don't think about anything at all. Let go of worries, concerns, and memories. Empty your mind of everything except the movements occurring right now. Don't think about the motions of your breath; just know them.

The process of watching, not *what* you are watching, is the meditation. Do not become identified with or absorbed by thoughts, feelings, or body sensations. When you become distracted, gently refocus your attention on breathing. Practice for 20 minutes or more. At the end of a meditation practice it is customary to share with all beings the benefit of your meditation. Say whatever words seem suitable to you, such as "May I share the benefit of my vipassana practice with all beings, so that they may be free of mental and physical suffering."

Centering Prayer

Centering Prayer is a method practiced and co-founded by M. Basil Pennington and Thomas Keating, Cistercian monks. In his book *Open Mind, Open Heart* (chapter 5), Keating presents the method of centering prayer as adapted from earlier teachings, such as *The Cloud of Unknowing*. Centering prayer is meant to enrich and enhance the discovery of God's presence within us and in all creation.

Method

Choose a sacred word as the symbol of your intention to consent to God's presence and action within. The sacred word should be chosen by asking the Holy Spirit what word is suitable for you. Examples include Lord, Jesus, Abba, Father, Mother. Other possibilities: Love, Peace, Shalom.

As you open your eyes and bring your attention back into daily life, keep the atmosphere of silence with you.

Sitting comfortably and with eyes closed, settle briefly and silently introduce the sacred word as the symbol of your consent to God's presence and action within. Allow everything outside you to slip away as you introduce the sacred word inwardly and very gently.

The anonymous author of *The Cloud of Unknowing* (chapter 32) instructs us well in the practice: "When distracting thoughts annoy you, try to pretend that you do not even notice their presence or that they have come between you and your God. For beyond them, God is hidden in the dark *cloud of unknowing*."

When you become aware of thoughts, return ever-so-gently to the sacred word. Thoughts include sense perceptions, feelings, images, memories, reflections, and commentaries.

At the end of the prayer period—ideally 20 or more minutes twice a day—remain in silence with eyes closed for a few minutes. As you open your eyes and bring your attention back into daily life, keep the atmosphere of silence with you.

The Amidah

The *Amidah* is perhaps the most important prayer of the synagogue. Among observant Jews, it is referred to as *Ha Tef illah*, or "the prayer" of Judaism and is recited three times a day while standing and facing the *Aron Kodesh* (the ark that houses the Torah scrolls). The basic form of the prayer was composed by the 120 Men of the Great Assembly in the fifth century BCE Today the *Amidah* is a main section of all Jewish prayer books. It consists of nineteen prayers; the following is the opening prayer, or *Avot*, Before reciting, say, "O Lord, open my lips and my mouth shall proclaim your praise." (Psalm 51: 17)

Then recite:

Blessed are You, O Lord our God and God of our fathers, the God of Abraham, the God of Isaac and the God of Jacob, the great, mighty and revered God, the Most High God who bestows loving kindnesses, the Creator of all, who remembers the good deeds of the fathers and who brings a redeemer to their children's children for his name's sake. O king, helper, savior and shield. Blessed are You, O Lord, the shield of Abraham.

Method

Amidah literally means in Hebrew, "that which involves standing." One should stand with one's feet together while reciting the *Amidah* as a show of respect for God. The rabbis add that this pose mirrors the vision of angels that Ezekiel had in which the feet of the angels appeared as one (Ezekiel 1:7). The custom is to face the direction of Israel; for this reason the ark is on the eastern wall of many synagogues in the West. Before one begins, it is customary to take three small steps back, and then three steps forward before reciting the *Amidah*. The steps backward at the beginning represent withdrawing one's attention from the material world, and then stepping forward to symbolically approach the King of Kings.

Note that the blessings should be recited while standing, with quiet devotion and without interruption. The worshipper bows during the recitation of the *Amidah*: when you say "Blessed are You, O Lord," bend your knees at "Blessed," bow at "are You," and straighten while saying, "O Lord."

The *Amidah* is a person's opportunity to approach God in private prayer, and should therefore be a quiet prayer of the heart. Whenever there is a *minyan* (group of ten) present, the *Amidah* will be repeated aloud (by the cantor) in the synagogue, and the congregant responds "Amen" after each blessing has been recited. The *Amidah* can be used as a repetitive meditation; it is best to memorize it and, if possible, study the original Hebrew.

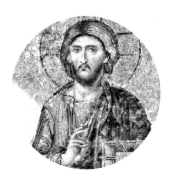

Hesychast Prayer

The Hesychast Prayer, meaning the quiet or silent prayer, can be traced back to the desert fathers and mothers. Hesychasm flourished, and continues to flourish, at Mount Athos, one of the great holy centers of Orthodox monasticism in northern Greece. Through this form of inner, mental prayer, Christian monastics taught that the human can participate in the inner life of God through the divine energies that are expressions of the divine nature or essence.

Also called the Jesus Prayer or the Prayer of the Heart, the Hesychast Prayer was brought to a wide audience through the wonderful and charming account of an anonymous pilgrim who in the nineteenth century walked through Russia reciting the name of Jesus. In his travels, he met an old monk who taught him to pray without ceasing, telling him to recite the prayer 3,000 times each day, then six thousand times, then twelve thousand times, whether standing or sitting or lying down. Soon he discovered the prayer was reciting itself and he found deep and lasting consolation.

His profound religious experience is recorded in the classical text *The Way of the Pilgrim*, where he draws from the collection of writings of Orthodox masters, called the *Philokalia*, on the practice of ceaseless prayer.

Method

Sit alone and in silence. Bow your head and close your eyes; relax your breathing and with your imagination, look into your heart. Direct your thoughts from your head to your heart. While inhaling, say, "Lord Jesus Christ, have mercy on me," either softly with your lips or in your mind. Endeavor to fight distractions but be patient and peaceful and repeat this process frequently.

Try practicing the Hesychast Prayer for two 20-minute periods per day.

The human person can participate in the inner life of God through the divine energies that are expressions of the divine nature or essence.

fostering a contemplative attitude

Describe the practices you tried from the list in this section. Which one(s) did you find most conducive to deepening a contemplative center?

Reflect on the kinds of meditations, body movements, prayer forms, writings, and other methods you use to nurture a contemplative attitude and to deepen your prayer or meditative life.

The sight and wisdom of the spiritual director is nourished by a contemplative heart and mind. A monastic or contemplative heart is one that is centered in its own Center, having found the source that is the one thing necessary. It is a quality of being that sees the world through eyes of compassion and love, directed to the Spirit that is Love itself. It is a heart detached from personal gain and free of self-interested desire. In this way of being, sharing between director and directee moves out of silence and stillness. Conventional social attitudes and goals are suspended. The director or the directee is not seeking approval, friendship, desire, praise, accommodation, and so forth, but the longing for wisdom. The journey inward is a path deeper and deeper into the experience and territory of one's own self. It is an attunement to how truth impresses itself on the body, mind, and spirit; how we avoid it; what the diversions and fears are that prevent us fromfinding it; how it nourishes our souls and sustains our hearts; and, finally, how we cannot live without it.

The desert monks called this inner wisdom purity of heart, which they associated with the inflow of divine love. The pure of heart gave God's love. Seeing the

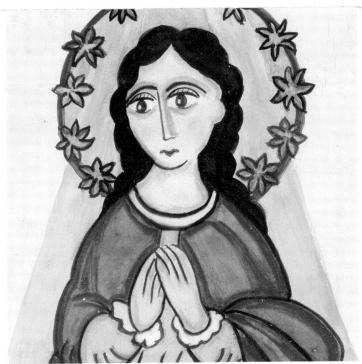

world from the silence at the center of being made them acutely aware that life itself offers us eternity. Our daily existence is the material ground for the liberation of our consciousness and the freeing of our souls. A director seeks to embody a contemplative quality of heart, remaining focused on an ultimate meaning as one's guiding star, with an inborn optimism that is the faith of the ancients: all is well that is healed in the Spirit.

<div align="right">a monastic heart and spiritual direction</div>

monastic heart

What do you do to maintain a monastic or contemplative quality of heart?

Are there situations or feelings that curtail an openness of heart?

What situations or experiences in your life foster deepening of heart consciousness?

There is a particular form of meditation that is helpful in sustaining the center point within the person, a practice that I have developed and termed the *Inner Monastery Meditation*. I have found this practice to be quite effective in deepening the ground of our beings, and in sustaining the contemplative silence capable of withstanding the activities and noise of life.

To begin our meditation, sit in a comfortable chair, with your back erect and feet on the floor. Close your eyes and feel the rising warmth of the earth coming up through your feet and the descending light of the spirit filling your mind from above. Breathe in the quiet wisdom of Mother Earth and the brilliant light of holy wisdom.

As you breathe in and breathe out, may your whole body, mind, and spirit be filled with attentive quiet and rest.

Allow all activity, words, and responsibilities to be stilled, as you breathe out the noise and conflict that draws you away from your true center.

inner monastery meditation

Focus your whole being and all your attention on your heart. Here at the very center of yourself is an inner hermitage, a holy monastery, where you and your Divine dwell together alone. This is your sacred home, and it may be any place and it may look any way, but it is where you and your Divine Source are One.

Breathe in and breathe out gently. Allow yourself to enter into the warm and inviting inner monastery, sinking into the Divine Presence. Feel your whole being come to rest. Slowly just sink down, letting everything go as you experience the freedom of being silent and still, vulnerable and intimate, open and receptive, alone with your Beloved.

As you breathe in and breathe out, feel how nothing is needed here; how nurtured you are; how you are in a paradise, one to One, heart to Heart.

Rest here in your inner monastery, allowing all your cares to be given away. Simply feel the wonder of never leaving your true home.

Make a vow or a commitment to live in your inner monastery, which is open to the whole world. Wherever you go and whatever you do, remain connected to the palace of rest in your heart. In this way, each day will be a meditation, as the light of your inner monastery illuminates the hidden mystery within life itself.

Wherever you go and whatever you do, remain connected to the palace of rest in your heart

How would you describe the experience of being in your inner monastery?

Practice being in your inner monastery while you are with family, at work, and when you meditate or pray. Did you find maintaining your center easy to do, or was it somewhat difficult?

inner monastery meditation

Mystical Anthropology

...the spiritual direction relationship moves from a realization that at the deepest core of the person there is a spark of the Divine, where our silence and God's silence meet, that remains untouched and holy.

Spiritual guidance is based on an understanding that the soul or primary nature of the person is inseparably connected to its transcendent source. Despite the pains, errors, and sins one may have inflicted or endured, the spiritual direction relationship moves from a realization that at the deepest core of the person, there is a spark of the Divine, where our silence and God's silence meet, that remains untouched and holy. This mystical vision of the self does not deny that we humans commit sins and endure suffering; however, it sees these painful conditions against the greater horizon of the radiance of the Divine that dwells in us.

We might call this view of the human person a "mystical anthropology," that is: Who is the person when seen from the perspective of the Divine? Every religion asks this question, and every religion's mystical tradition answers in a similar way: at the height of the spiritual life, ultimate reality and the true self are one. This essential insight is expressed through complex and diverse philosophies in the world's religions.

Judaism

Buddhism

Native
American

African

The Divine Self

Hinduism

Islam

Daoism

Christianity

a mystical state that follows *devekut*, involving not just cleaving but some form of self-annihilation of the human personality, which absorbs or integrates the soul into the universal.

Here, the human soul penetrates into the inner part of the divine light, and is treasured or stored in the divine light. This crowning or adorning of the soul of the mystic into the radiance of divinity effects a transformation marked by a permanent or infused state of integration.

Judaism

In Judaism, one way of expressing the unity of self and God is through the concept of "*devekut*," meaning universalization, integration, and fusion with the divine.

Devekut, cleaving, is derived from the Hebrew word *davak*, meaning being devoted to God. In the Jewish mystical path, *devekut* is perceived as the highest step on the spiritual ladder by which the transformation of the individual soul into a universal one or God occurs.

In many texts, it is generally agreed that *devekut* in the world is fleeting and that only after death can true unity be achieved. However, other examples indicate

When man cleaves to God, it is very delightful for Him, and very savorous for Him, so much so that He will swallow it into His heart, . . . as the corporeal throat swallows. And this is true cleaving, as he becomes one substance with God in whom he was swallowed, without being separate [from God] to be considered as a distinct entity at all. That is the meaning of the verse and you shall cleave to Him (to cleave) literally.

—*Rabbi Shneor Zalman*

In Mahayana Buddhism, *nirvana* is conceived as oneness with the absolute and liberation from attachment, which leads to the realization of the unity of *samsara* and *nirvana*.

The vision of the true nature of phenomena is realized by the mind of enlightenment, *bodhichitta* (Sanskrit, "awakened mind") or mind freed from illusion.

Buddhism

The interpenetration of all realms is formalized in Buddhism through an identification of *samsara* (conditioned reality) with *nirvana* (enlightenment).

Samsara, from the Sanskrit "journeying," refers to the cycles of existences, or succession of rebirths that a being goes through until it has attained liberation and entered *nirvana* (Sanskrit, "extinction").

The goal of spiritual practice in Buddhism, attainment of *nirvana*, requires complete overcoming of the three unwholesome roots—hatred, desire, and delusion—and freedom from the causes and effects of karma.

> Shariputra, form does not differ from
> emptiness;
> emptiness does not differ from form.
> that which is form is emptiness:
> that which is emptiness, form.
> The same is true of feelings, perceptions,
> impulses, consciousness.
> Therefore know the *Prajna Paramita*
> [transcendent wisdom]
> is the great transcendent mantra,
> is the utmost mantra,
> is the supreme mantra,
> which is able to relieve all suffering
> and is true, not false.
>
> —Excerpt from *The Heart Sutra*

Nirvana is conceived as oneness with the absolute and liberation from attachment.

While there is a hierarchical relationship in the divine cosmology, the belief in the all-pervading presence of God sustains the holiness of the universe. The African view of the world is nourished by a spirituality founded on the Supreme God, and other divine beings that are associated with God.

As God is the foundation of life, so nothing happens without God. *Woyengi* is eternal and does not die, and so humans do not die. In the Yoruba religion, humans live on even after they die to their physical bodies.

African Religions

The breath of *Olodumare* and the divine origin of the human spirit are eternally united in African spirituality.

In the creation stories of the Yoruba people of southern Nigeria, *Olodumare* (God), or *Woyengi* (Great Mother), breathes life into all human beings. Thus, the whole universe is endowed with a sacramental nature; and the human spirit, which is of divine origin, lives immersed in and returns to the all-pervading power and presence of the Source Being.

> In the beginning *Woyengi* seated herself on a stool and with her feet firmly planted on the Creation Stone and a table before her, she began to mold human beings out of earth. As each person was completed, each became a living being as the Great Mother breathed into each.
>
> —Nigerian Creation Story

This idea of *theosis*—or becoming divine-like—is rooted in the biblical account and serves to illustrate the explicit place mystical union holds in the life of the spiritual pilgrim.

Depicted in the language of love and longing, and in radical anguish and despair, the soul journey is a continual ascent into deeper dimensions of hiddenness and glory, until it realizes, as St. John of the Cross said, that "glad night" when lover and beloved are reunited.

Christianity

In Christianity, *unio mystica* (mystical union) and sometimes mystical annihilation between the soul and God or Jesus signify the unity of being.

In Christian mysticism, there exists a wide range of experiences depicting various states of divine union, absorption, cleaving, or annihilation.

The whole of the Christian spiritual journey can be found on the promise first made by its early theologians that "God became human so that humans could become God."

Deep-cellared is the cavern
Of my heart's love, I drank of him alive:
Now, stumbling from the tavern,
No thoughts of mine survive,
And I have lost the flock I used to drive.
He gave his breast; seraphic
In savour was the science he taught;
And there I made my traffic
Of all, withholding naught,
And promised to become the bride he
sought.

—*St. John of the Cross*

The path of liberation for the Hindu comes by way of knowing the nondualism (*advaita*, "not two" in Sanskrit) of the universe. Thus, one arrives at the one unity principle and true self, *aham asmi Brahman*: I am Brahman.

In this advaitic state, the true self realizes that it is also the divine self, *sat, chit, ananda*: eternal, absolute being; absolute consciousness; and absolute bliss.

The path of liberation for the Hindu comes by way of knowing one true self and the nondualism . . . of the universe. . .

Hinduism

Hinduism eloquently posits that *atman* (immortal self or soul) is *Brahman* (Eternal, Imperishable Absolute); self and God become completely identified, like sugar dissolved in water or salt poured into the sea.

In Hinduism, *Brahman* is located both in the physical, external world and also in the spiritual and inner world as Atman.

Every human being has an eternal soul or true self (atman), which is a microcosm of Atman, the universal spirit, or Brahman.

> That which is invisible, ungraspable,
> without family, without caste,
> Without sight or hearing is, It, without
> hand or foot,
> Eternal, all-pervading, omnipresent,
> exceedingly subtle;
> That is the Imperishable, which the wise
> perceive as the source of beings.
> As a spider emits and draws in its thread,
> As herbs arise on the earth,
> As the hairs of the head and body from a
> living person,
> So from the Imperishable arises
> everything here.
> —*Mudaka Upanishad*

This spiritual path involves emptying the mind and sitting in oblivion so that the person will forget himself or herself, freed from mental chaos and attachment to material objects. Then, humans will become fully at-one with the Dao; they will be free and wandering, open to the universe in all of its spontaneous dimensions.

Daoism

Zuowang, "sitting-in-forgetting," is the closest description of the experience of ecstatic union with the Way in Daoism.

In the Daoist mysticism of Zhuangzi, the Dao is the eternal Absolute—without beginning or end—always present everywhere. It is the maternal, flowing, self-generating, organic movement of the universe.

In developing consciousness, humans became separated from the Dao; in order to return to their true nature, Daoism contends that humans need to realize that all things are equal, all things are the Dao.

> I see nothing
> With the eyes. My whole being
> Apprehends.
> My senses are idle. The spirit
> Free to work without plan
> Follows its own instinct
> Guided by natural line,
> By the secret opening, the hidden space,
> My cleaver finds its own way,
> I cut through no joint, chop no bone.
>
> —*Zhuangzi*

The spiritual realm exists in a state of timelessness and cyclical return and is considered by some to be the reality behind reality that reveals the true Unity of all that exists. At the center point of the circle stands the human, with feet on the ground and head in the sky. Humans realize their true self by finding harmony with nature and spirit, opening themselves to experience fully all that is around them.

The Lakota journey toward integration and contact with *Wakan Tanka* involves sacrifice, vision quests, and reverence for nature. Since the physical realm is the embodiment of the spirit realm, there is no separation between the natural and the supernatural order.

At the center point of the circle stands the human, with feet on the ground and head in the sky.

Native American

Native American traditions express the unity of being through the mutual indwelling of *Wakan Tanka* (Great Mystery–Sioux), *Orenda* (spiritual power innate in all things–Iroquois), or *Kitche Manitou* (Great Spirit–Ojibwa) in the human person and all creation. The Lakota Sioux, of the North American plains, understand that every object in the world has a spirit and that spirit is *wakan*, or mystery. All of life has spirits and all spirits—including the two-legged and the four-legged—belong to the great circle of creation. This great circle is governed by the *wakan* beings who are never born and never die.

> The Six Grandfathers have placed in this world many things, all of which should be happy. Every little thing is sent for something, and in all things there should be happiness and the power to make happy. Like the grasses showing tender faces to each other, thus we should do, for this was the wish of the Grandfathers of the World.
>
> —*Black Elk*

Islam

Islam extols the eternal unity of being through the concept of *fana*, the passing away or annihilation of self in Allah.

For Sufis (the mystical tradition of Islam), deep within the heart there is the longing of the soul separated from its source. This pain of longing comes from the memory of when we were together with God.

Fana is a cornerstone of the Sufi path, and refers to the loss of ego that occurs in a soul driven by an intense desire to go back home to God.

One of the sayings attributed to the prophet Mohammad encapsulates the spiritual state of *fana*: "To die before you die." The Sufi desires conscious remembrance of divine union in this life through a continual process of ego releasement—to die to the "I" that separates us from God.

This is a painful part of the spiritual journey because it requires a surrender of the whole self to love. The Sufi who sets out to seek this original union with Reality (*fana fi'l-Haqq*) is called a "traveller" (*salik*), who advances by slow "stages" (*maqamat*) along a path (*tariqat*).

> If you could get rid
> Of yourself just once,
> The secret of secrets
> Would open to you.
> The face of the unknown,
> Hidden beyond the universe
> Would appear on the
> Mirror of your perception.
> —Jalāl ad-Dīn Rumi

mystical anthropology

Describe the similarities in the concept of the divine self in the various world religions.

What aspect of this divine-human relationship is most compelling to you?

How does the unity of divine and human either align with or differ from your experience or belief?

Visions of the Soul in Mystical Traditions

While the person may suffer harm from his or her encounter with life, there is—imprinted in being itself—the everlasting possibility of access to pristine consciousness, to Love itself.

Among the world's spiritual traditions is found an amazingly similar mystical anthropology, which describes the inner core or soul of the person as being fundamentally inseparable from its divine source. The word "soul"—and its related terms, *atman, nafs,* etc.—is a cipher, a poetic reference to the deep self, to that which exceeds materiality, to the imprint of the Divine within. This super-sensory reality holds the power of transformation and renewal intrinsic to each person, and imparts to the mystic, psychic, and material realities the capacity to participate in the hidden divinity that exceeds naming. In addition, using diverse languages and symbols, religions posit that the entire soul is one and divine, conceptually divided into two states or qualities of consciousness. The lower soul or consciousness turns toward the world and is susceptible to being wounded or damaged by it. The higher or supernatural consciousness, however, is centered in primordial, untouched, perfection. It is this juxtaposition of purity and vulnerability, love and injury that signifies the mysterious hope of personhood. While the person may suffer harm from his or her encounter with life, there is—imprinted in being itself—the everlasting possibility of access to pristine consciousness, to Love itself.

Teresa of Avila, the sixteenth-century Spanish mystic and founder of the Discalced Carmelites, describes in some detail the relationship of the divine presence in the soul. In *The Interior Castle*, she writes: ". . . the soul of the just person is nothing else but a paradise where the Lord says he finds his delight . . . I don't find anything comparable to the magnificent beauty of a soul and its marvelous capacity. Indeed, our intellects, however keen, can hardly comprehend it, just as they cannot comprehend God." (I.1.1)

She conceptualizes the soul as a crystalline castle with seven *moradas* (rooms or dwellings). The three outer or lower *moradas* are turned toward the world and are susceptible to its influences, sins, and distractions. The four interior or higher rooms of the soul are turned toward God and are supernatural, untouched by the conditions of ordinary reality.
See diagram on page 63.

At the center of the soul God dwells, radiating light out to the whole castle; here the soul and its Beloved are joined in mystical marriage in an inseparable unity that is likened to rain falling from the sky into a river. Because of the purity of the soul in its center, Teresa is insistent that while sin can mar one's ability to connect to God, it cannot permanently damage the soul or effect its loveliness and splendor:

"It should be kept in mind here that the fount, the shining sun that is in the center of the soul, does not lose its beauty and splendor; it is always present in the soul, and nothing can take away its loveliness. But if a black cloth is placed over a crystal that is in the sun, obviously the sun's brilliance will have no effect on the crystal even though the sun is shining on it." (I.2.3)

soul in christian mysticism

Teresa's words convey the uplifting hope at the heart of mysticism—that the true self is always one with God. It can never be separated from its divine lover, even though its brilliance may be tarnished or covered over with the black cloth of sin and error.

Her vision of the soul as conceptually divided between higher and lower levels of consciousness finds resonance in the thought of other Christian mystics as well. The fourteenth-century English mystic, Julian of Norwich, distinguishes the higher from the lower soul using the terms "substance" and "sensuality," developing a vision of the inherent goodness of the soul despite its fractures and sins. Meister Eckhart makes an even more radical identification between the inner soul and God: "I have often said there is something in the soul which is so akin to God that it is one (with God) and not merely united with Him. . . . My eye and God's eye are one eye and one seeing and one knowing and one loving." (Sermon 12, *Qui audit me*)

Image of Soul in *The Interior Castle*

Entrance to the castle
is through prayer, and
the soul's progress
moves parallel to the
progress in prayer,
from the lower to
higher soul. Medieval
theologians held
that human sin
caused effects in
soul consciousness,
dividing the lower
soul from the
higher and turning
it away from the
divine good.

These soul
fractures create
self-alienation and
woundedness at
the center of the
personality. Although
sin is responsible for
the split between the
inner and outer soul,
it can never penetrate
or fundamentally harm
the soul's perfection,
which always remains
pure and untouched
in its center. Thus,
the re-integration of
the soul, according to
Teresa and Julian, can
only be performed by
God, who alone heals.

*God heals soul from
the inside out*

Wound

Fracture

*At the
center
of the
soul God
dwells,
radiating
light out
to the
whole
castle.*

Inner or higher soul
turned toward God
Mystical—untouched by sin.
(Julian's "Substance").

**7.
Spiritual Marriage
or Perfect Union.**
God and Soul
are one.

Outer or Lower Soul
turned toward world
and affected by sin
(Julian's "Sensuality").

6. Spiritual Betrothal.
Courage to be joined
with God.

5. Prayer of Union.
Love of God for God's
sake alone.

4. Prayer of Quiet or Infused Recollection.
Passive experience of
God's light.

3. Ascetical Prayer.
Long not to
offend God.

2. First Steps in Prayer.
Strive for
God's will.

Dwelling 1. Need for Prayer.
Soul absorbed in
worldly affairs.

Entrance to the castle is through prayer.

soul in christian mysticism

How does Teresa's notion of the eternal goodness of the soul relate to your religion of birth and to your own spiritual understanding?

Envision your inner life or soul as an organic whole, having seven levels of depth. Meditate on the movement of consciousness from the outer or worldly levels to the most interior or spiritual states, where the Divine dwells. Describe what you learned during the meditation, including any feelings, sounds, thoughts, and visions.

In Jewish mysticism, the soul is divided into five states of consciousness, in which the two lower soul levels, *nefesh* and *ruah*, are affected by the way we live our lives, while the upper three, *neshama*, *chayah*, and *yehida*, are always connected to God and remain untouched.

Kabbalistic Flame

○ **Yehidah**
World of Will:
unity, cannot be separated from God. Pure, higher consciousness.

● **Hayah**
World of Emanation:
living essence, *devekut* (integration) dwells here. Pure.

● **Neshama**
World of Creation:
breath, different quality than human consciousness. Pure.

● **Ruah**
World of Formation:
spirit, emotions, and speech. Corruptible.

● **Nefesh**
World of Action:
animal, lower, soul connected to the world. Corruptible.

soul in jewish mysticism

Guided Meditation for the Flame
by Rabbi Goldie Milgram

You can do this on your own or with a group. If with a group, let your guests know you have guided visualization to share which will involve some chanting first, and some silence afterward. Tell them you will let them know when to emerge from the silence which will last for a few minutes.

Focusing softly on the flames, begin to chant from psalms the sacred phrase: "In Your Light, We see light, *B'or-khah, Neereh Or*, In Your Light." Recite this together slowly, over and over, let it become a chant. Very slowly take them through each of the levels of soul in the diagram. Be sure to leave quiet time between each level. Reflecting on each level can be very interesting and pleasurable and deserves time.

Nefesh. The blue core of the flame, is the first level of soul. This is where you sense your soul and body connect, your center of vitality.

Ruah. The yellow band of the flame, this is the layer of anger, joy, sadness, your feelings.

Neshamah. The orange band of the flame. You are more than your feelings, you have another level of soul: your personality, thoughts, memories, opinions, and innovations.

Hayah, the black farfrizzlings that come off into the air as the flame burns, represents your intuition. This is also the quality of soul that helps you to stay alive during times when it feels like you are crawling on the ground with your fingernails to survive, to tolerate the sometimes pain of life.

Yehidah, the candle heat and light. Who can say where this begins and ends? This is where your soul is unified and undifferentiable from all Being. This is where you occupy space in creation, you are needed and particular and contribute uniquely and at the same time you are in *Yechidut*, unity as the drop of water is with the ocean, as the leaf is with the tree, as the heat and light of the flame is simultaneously part of the shining of the original light of creation.

Hold a really long silence at the end and then as people come back to a group awareness, invite sharing. Please don't require sharing of anyone. Whenever you invite sharing, it might be worthwhile to note the "and" method. If someone says something about which you feel differently, rather than invalidating them by saying they are wrong, say "and, what works nicely for me is…" or and "what I am noticing is…."

Sometimes when I do this meditation, I sense the expanding flame of each soul in the room along with me, radiating through shining faces and great hearts far beyond each physical body, a light that comes through us from a Source born long before we were and suddenly: the menorah of humanity is revealed.

Still and all, reporting on my mystical experiences isn't having your own. Hopefully the reading is pleasurable and stimulates useful thoughts, possibilities, and feelings. Even so, it is much like showing a postcard of a fountain, or picture of someone flying a plane—the words on the back are "having a great time, wish you were here."

It's your turn to try the flame.

http://www.reclaimingjudaism.org/teachings/guided-meditation-flame

In the Sufi traditions, every soul is a paradise; this primordial reality is veiled in every soul but can manifest itself through spiritual practice based upon sustained invocation (*dhikr*) or repeated remembrance of the Name of God. In this way the center of the personality becomes activated. The human personality has three aspects: *ruh* (spirit); *qalb* (heart); *nafs* (soul). The progression of a soul involves movement from the lower to the higher and incorruptible level of *nafs*.

Nafs al-ammarah: the commanding self, attached to lust and egoism; includes the animal self (*nafs al-hayawaniyyah*), passively obedient to natural impulses.

Nafs al-lawwamah: the blaming self, touched by Allah's mercy and aware of its own imperfections and need to repent.

Nafs al-mulhimah: the inspired self, ascended through effort to constantly seeking forgiveness and inspired by love.

Nafs al-mutmainnah: the tranquil self, at peace and reintegrated in the spirit; secure and at rest in certainty.

Nafs al-radiyyah: the content self, able to treat ease and hardship the same because every action is from Allah alone.

Nafs al-mardiyyah: the gratified self, where the light of the heart is completed, advancing from wholesomeness to total awe.

Nafs al-kamilah: the perfect self, the station of completeness of beauty, where the servants enter the light of the Beloved.

soul in sufi mysticism

atman in hinduism (vedanta)

In Vedanta, one of the six philosophical schools of Hinduism, the entire universe is a single Reality. There is only one Great Being, *Brahman*, which is utter Consciousness, and the essence of *atman* (self, soul) of all beings. *Tat tvam asi* ("That art thou") is one of the great truths of the *Upanishads*. Since the One Being is our essential core, we can realize it through proper discernment (*viveka*) and renunciation (*vairagya*).

LEVELS OF CONSCIOUSNESS	SPIRITUAL STAGES
Vishva—waking, conscious, gross • *dual, outward-oriented*	Awareness of the Self Within as (incorrectly) separate
Taijasa—dreaming, unconscious, subtle • *dual, active, inward-oriented*	Recognizing the "I-within" with the Self
Prajna—deep sleep, subconscious, casual • *dual, latent, inactive*	Direct realization that Atman is Brahman, that there is no difference between Self and Absolute
Turiya—nondual, consciousness, Absolute • *Self-realization*	Experience of "I am That," or "I am the Absolute" *Tat tvam asi*

Experience of realizing that Brahman is the ALL that exists as well as that which does not exist.

A*natman* (no-soul, no-self) is the Buddhist doctrine that there is no underlying substance that can be called the soul. Even Buddha nature is not an objective entity or conceptual reality. It is open and empty awareness itself and does not possess any invariable, definable characteristics.

While Buddhism does not address levels of the soul, it does speak to states of consciousness and stages of enlightenment, which move from the separated self and worldly knowledge to nondual, pure consciousness.

LEVELS OF CONSCIOUSNESS	SPIRITUAL STAGES
Senses – Consciousness (sight, hearing, taste, touch, smell)	Preparatory foundation in worldly knowledge
Mental – Consciousness	Stream-Enterer (*Srotāpanna*): encounters the no-self, no longer sees self as separate, lets go of attachment to rituals, dedication to the path Once-Returner (*Sakrdāgāmin*): direct insight into no-self, reduction in attachment and aversion
Deluded/Tainted Awareness	Non-Returner (*Anāgāmin*): hint of a self-sense remains, trace of restlessness and dissatisfaction, partially enlightened
Pure Consciousness	*Arahant* – Full enlightenment, no trace of separate self

All conditioned things are impermanent,
All conditioned things are Dukkha — Suffering,
All conditioned or unconditioned things are soulless or selfless. (Dhammapada 277, 278, 279)

consciousness in buddhism (theravada)

In each of these traditions, movement into deeper levels of consciousness occurs through meditation and prayer. For example, Teresa of Avila contends that beginners on the path generally are familiar with active forms of prayer—vocal prayer, reading of sacred texts, and communal prayer. Those more advanced move into deeper states of contemplative prayer that Teresa describes in various ways—prayer of quiet, prayer of union, prayer of ecstatic rapture—as an intimate sharing between friends. All forms of prayer in the interior dwellings are contemplative, and Teresa distinguishes them from the outer or more active prayers. Active consolations, she contends, begin in the person and reach toward God, while passive (contemplative) prayer is initiated by God, and is received in human nature.

From this mystical or passive perspective, then, the movement that occurs in a person's inner life is activated by the Divine itself, as it touches or wounds the soul in its depth. Further, healing of interior suffering and awareness of spiritual longing and pain emerge from the spark of divinity in the center of being, as divine energies move from inside of us out into consciousness to heal and restore. It is a common sentiment among mystics and spiritual directors that what we feel in our depth—joy, sorrow, longing for love, fear of change—has been initiated by the Spirit first in order to lead us closer to divinity and to the hoped-for freedom of wholeness and divine intimacy. This mystical insight of the ultimate unity of the person and divinity is essential to any spiritual direction relationship insofar as it provides the director with a stable platform upon which to live and practice one's ministry.

Search online or in the library for further information on the nature of the soul in Judaism, Sufism, Hinduism, and Buddhism. What elements did you find to be similar? Which were different?

Were there any elements of these diverse visions of the soul that were particularly meaningful for you or that evoked distinct spiritual feelings?

soul in jewish, sufi, hindu, and buddhist mysticism

Inner Life and Religious Experience

Religious experience is not confined to conventional notions of the religious, but is more aptly understood as an awareness that is present wherever there is an immediate apprehension of truth, divinity, or awe.

role of spiritual director

Spiritual direction is concerned with a person's experiences, especially religious experiences. Spiritual direction is thus involved with the whole range of religious phenomena common to the spiritual life: prayer, meditation, vision, inner voice, techniques of contemplation, feelings of grace and awe, ritual, liturgies, fasting, healing, awareness of energies, and so forth; as well as the more intellective varieties of experience, such as insight through divine reading (*lectio divina*), study of scriptures, and scholarly learning.

Religious personalities throughout history have documented and described various types of religious experiences. Among these must be included the third-eye visions, trance states, yogic postures, prostrations, and chakra and chi energies common to the religions of India, Tibet, and Southeast Asia. In the Western monotheisms, using different vocabularies, religious experience also includes visionary states (seeing with the inner eye), locutions (hearing with the inner ear), experiential prayer forms, sacred dance (such as the Sufi whirling dervishes), and mystical illuminations or trance. For example, in *The Book of Her Life*, Teresa of Avila explicitly distinguishes three kinds of visions and three types of locutions.

Three Types of Visions:

♦ Intellectual, that can be felt and known
 (chapter 27.3).

♦ Imaginative, perceived with the eyes of the
 soul, through imagination or fantasy
 (chapter 28).

♦ Corporeal, seen with the bodily eyes
 (chapter 28.4).

Three Types of Locutions:

♦ Explicit, heard with the sense of hearing
 (chapter 27.2ff).

♦ Explicit, not heard with the bodily ears,
 although they are understood much more
 clearly than if heard *(chapter 25).*

♦ Not explicit, just as in heaven one understands
 without speaking: God and the soul understand
 each other only through the desire His Majesty
 has that it understand Him, without the use of
 any other means *(chapter 27.10).*

Religious experience, however, is not confined to
conventional notions of the religious, but is more aptly
understood as an awareness that is present wherever
there is an immediate apprehension of truth, divinity,
or awe. Such moments may occur in states of prayer,
communing with nature, in response to animals and
other living creatures, in times of trauma or emotional
stress, and in other life situations which take us
outside the ordinary frame of reference.

Further, religious experience not only appears under
the categories we normally associate with such, but it
can also mean conflict, pain, dividedness, despair, fear,
anger, doubt, and impasse. These painful and often
dark night experiences can be areas of intense spiritual
growth, for here too we are called to an awareness of
something deeper and more profound.

It is through the variety and scope of religious
experience, and the increasing awareness of these
deeper feeling and visionary states, that we come to
wisdom, and to an understanding of the intimacy that
we share with the entire cosmic-divine sphere. These
moments—whether of joy or sorrow, conflict or
illumination—change our orientation to life, and often
are accompanied by intense feelings or intuitive visions
that cannot be fully captured in language.

inner life & religious experience

Describe any religious experiences you have had. Would you say they were primarily visual, auditory, intellective, or affective?

What form(s) did these religious experiences take: with divine figures, in nature, through study, in prayer?

Have you been aware of painful or dark experiences as well as those of joy, awe, or light?

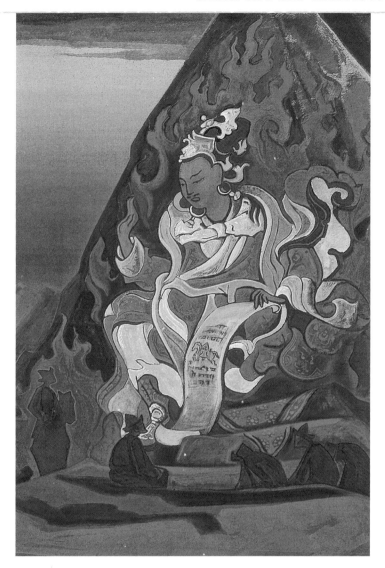

spirituality is by definition unrelated to the different human experiences we have as women and men of diverse races, ethnicities, religions, and economic and cultural backgrounds. However, those involved in caring for others recognize that our human experience, historical location, and varied social, racial, and sexual orientations impact on the spiritual life and on spiritual direction.

The idea that spiritual direction, by virtue of its association with the Spirit, is universal and transcends the social condition is to misapprehend how embodied and interdependent the Divine is in the world. Those things that wound the human spirit—and lead to loneliness, doubt, pain, and despair—are often the direct result of rejection, exclusion, violence, or prejudice inflicted by other members of the human community. The harshness, insensitivity, and other cruelties that we find in the world at large have a direct impact on the inner life of the person and the health and wholeness of our spirits.

There is a common tendency to associate the spirit and the spiritual with a transcendent, other-worldly place; and to assume that

In spiritual direction it is important to realize that there is no such thing as a stereotypical spiritual life. Every spiritual journey is unique; every person

human experience and spiritual direction

is guided to his or her source through an intensely individual process that is remarkably similar across cultures in terms of desired transformation and goal. Thus, while spirituality is a universal phenomenon that elevates and transforms the human condition, it is also profoundly related to community, society, and the larger social environment in which we live.

Spiritual directors now are more aware that differences in race, gender, and background— as well as social acceptance or marginalization, sexual orientation, and religious exclusiveness or shunning— affect people in distinct ways. These abuses often cause individuals to sustain particular types of soul wounds that must be compassionately understood and healed in order for a person to become truly whole.

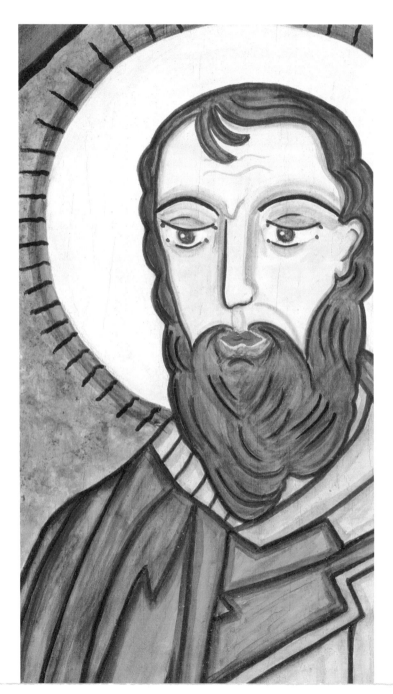

Have you experienced particular spiritual wounds because of your gender, race, sexual orientation, ethnicity, or other perceived difference?

Reflect on these experiences and how they have impacted your spiritual growth and development.

JOURNAL

human experience and direction

deep currents of spiritual feeling

The most significant means of tracking the movement of the spirit is to become aware of the deepest current of spiritual feeling within the person, a realm more profound and subtle than outer emotions, personality traits, or superficial ego needs. Instead, the deepest river of feeling is the speaking of the spiritual heart, and the innate desire and affective divine longing within us. It is the true self, the ground of being, or the source of knowing that seeks to express itself through the complexity of mind-body-spirit. It is often the still, small voice that is the least noticed of our inner life.

In spiritual direction, the subject of inquiry is the level of experience and feeling, the current of the heart, and not rational knowledge. In emphasizing the value of spiritual feelings and experience, both director and directee are open to another way of knowing and decision-making, and another way of listening and guidance. Here, inner feelings and deeper stirrings are the premier signs for investigating, participating in, and learning about the movement of the spirit.

The spiritual current of feeling is deeper, more powerful, and more silent than emotion, the conventional self, or the façade of personality we present to the world. It is here, in the living stream of meaning that courses through our lives, that we finally discover, and give ourselves permission to claim, what we have been dimly looking for. As we gather the courage to truly listen to our own deepest

feelings, we find The Holy within ourselves. Here, what brings us happiness or sorrow, consolation or desolation, peace or agitation, silence or noise, light or darkness, fragmentation or wholeness are signs of the spirit living in and communing with us.

One of the most difficult aspects of the director-directee relationship is remaining attentive to the distinction between rationality (mind, cognition, interpretation, analysis, judgment, intellectual understanding), psychological emotion, and the deep current of feeling that is the heart's guidance to one's own truth. While each of these aspects of the human person are inextricably interconnected, the focus of spiritual direction is equivalent to putting a magnifying glass on this often hidden and unspoken, but longing to be seen and heard, dimension of the person.

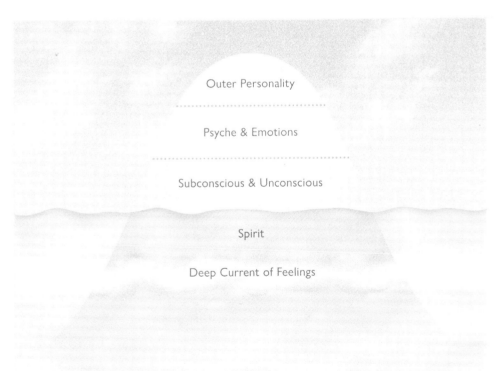

Outer Personality

Psyche & Emotions

Subconscious & Unconscious

Spirit

Deep Current of Feelings

Visualize Levels of Feeling

Imagine the current of spiritual feeling as submerged beneath the outer personality and deeper than psyche, emotions, and even the subconscious and unconscious. This iceberg image serves to illustrate how the upper levels of our emotional life and personality conceal what is felt on the level of soul and spirit. By becoming aware of this deep current within us, we learn to be attentive to the subtle manner in which our whole being seeks to communicate through mind, body, and spirit.

currents of spiritual feeling

Are you aware of deeper spiritual longings within you? How do you recognize or respond to them?

Visualize the deep current of feeling within you. Meditate on this stream of longing. Where is it calling you?

Reveal courageously even the greatest of your secrets, disclose to
him the mysteries of your soul, as the patient uncovers his wounds
to the physician, and you will obtain healing.

—Gregory of Nyssa

Spiritual direction also depends on a disclosure of thoughts. The unveiling of thoughts brings to the conscious mind tendencies that may be lurking deep in the heart where they cause havoc because they are not named or shared with anybody. This disclosure of thoughts, however, is not a rational analysis of the mind, but a revealing of the thinking process, the structure of thought itself, and the pre-conditioning that forms a residue in the memory of the person.

By becoming conscious of certain tendencies and habits of being, the person learns how to let go of and move beyond the conventional self. Thoughts, for example, of one's worthlessness, doubt, jealousy, despair, or insignificance are important; similarly, thoughts about the nature of God, the self, or the veracity of religion are all important themes that come up in spiritual direction.

disclosure of thoughts
in spiritual direction

Whatever you do, no matter how insignificant it might be, it is necessary that you be sincere and truthful. Sincerity means that you remove all creatures from your path, while truth means that you remove yourself from your path. When you reach this stage and cut across this treacherous wilderness, hypocrisy will have no claim on you, nor will any wonder be able to influence you. When these two veils are removed, no further veil remains between you and the divine threshold. When you are welcomed into the arbor of intimacy, . . . all will be disclosure and light!

—Sharafuddin Maneri, *The Hundred Letters*

Are you comfortable with disclosing your interior thoughts?

Would you consult a spiritual guide to assist you in uncovering interior thoughts?

What would you do to help another person to open his or her heart to interior preconditioning and habituations of the spirit?

disclosure of thoughts

The Role of Spiritual Director

The spiritual director, in his or her role, is an instrument of the Spirit.

role of spiritual director

Much has been written on the spiritual director and her or his role in the individual's faith journey. Among the various functions the spiritual director fills in this ministry is to serve as a wise elder, spiritual companion, or empathic listener willing to share in and learn from the deepest heart concerns of another person. In effect, the role of the spiritual director is to be a contemplative, caring presence. Three spiritual qualities of heart help us to understand and identify this essential contemplative dimension of spiritual direction.

Listen with one's whole being.

The primary role of the spiritual director is to listen "with the ear of the heart," as St. Benedict said. Empathetic listening involves listening from your heart, bearing the directee's words and wounds in your heart, and responding from your heart. The spiritual director, in his or her role, is an instrument of the Spirit. The Divine alone is the true director as God uses our whole personality—our gifts, knowledge, wisdom, experience, prayer life, as well as our weaknesses, biases, and inexperience—as signs to assist another on the journey, and as a means of growth in our souls. In listening to the directee's story, with one's whole being and whole heart, a mysterious communion takes place that allows us to read how the spirit is seeking to be expressed through the particular life journey of our soul friend. To listen in this way is to participate in a sacred act, in which the holiness of the other person and the holiness of self coincide in one's heart.

Guide with humility and silence.

As a spiritual director, the most important attitude is humble awareness that spiritual direction already exists within the directee. We have to listen for this direction in silence and awe, without providing advice or imposing predetermined solutions. In effect, guidance is an abandonment to the Spirit within us, it is detachment from the desire to give directees any particular directive or insight or for immediate and tangible solutions to difficulties. We wait in humble silence for what is given, not what we want or expect. Guidance is imparted only when moved by the Spirit to do so. The spiritual director relies on following and being attuned to the movement of divine wisdom within the self. The director gently assists the person in discerning what brings one closer or further away from one's true source by: paying complete attention to what is said; assisting in clarification; raising questions when directee wants them; and helping directee to recognize the affective attitudes that influence his or her relationship with the sacred.

Encourage and affirm the journey.

There are few books or words of wisdom that can guide us through the landscape of the inner life. What assists us in these moments is what the desert monks called *intentio*, the passion of one's whole being to focus solely on the way to truth, and to follow one's longing to be centered in love. This passionate commitment to dwell in the loving knowledge that is imparted by the spirit alone fosters an atmosphere of hopeful expectancy and prayerful encouragement. The spiritual director, then, as a person who is sincerely open to the gifts of the spirit and who has traveled along the sometimes steep and dusty roads of the inner journey, is able to be a source of affirmation and encouragement in the lives of others. She or he is able to have compassion for another person's soul wounds, doubts, and despairs, and to hold these sufferings in the light of the greater freedom and intimacy toward which we are called.

discernment in spiritual direction

The whole concern of the director should be not to accommodate souls to his own way or to what suits him. Rather he ought to see if he can discern the particular way which God is leading them. If he cannot discern the way proper to each, he should leave them alone and not disturb them.

—St. John of the Cross

One of the central elements of the spiritual direction relationship is discernment: listening with the heart to the movement of the spirit. Discernment identifies the subtle way in which the Divine is at work in an individual or community, communicating our deepest longing and need. Discernment is the process that maps the spirit: how the disclosure of thoughts and the sweep of feelings sensitizes the spiritual director to read the marks of spirit as it touches the inner life of the person.

Discernment is a subtle form of spiritual knowing, which

* is attuned to the path of one's divine or higher will.
* listens for the nuances that draw a person closer to the Divine.
* reads the signs and markers of spiritual growth in the person.
* is detached from personal gain or an imposed outcome.

The goal of discernment in spiritual direction is to guide others deeper and deeper into the quest for wholeness and healing, and toward intimacy, meaning, and love. Discernment is the listening with your whole heart and whole being in order to touch upon and participate in a more real and authentic intuitive knowing.

The process of discernment is challenging because the director is attuned to the different movements at work within the person, including the struggle that often occurs between the lower will and desires and the divine will and love; and habits accumulated in the lower or conventional self that prevent the directee from becoming aware of the hidden motives, contrary desires, and conflicted needs at work within the person.

Practice listening with the ear of the heart. How does your awareness of others differ when you listen this way?

Spiritual guides throughout history have emphasized the power of discerning the movement of the spirit. Look back at your life. At what points do you feel spiritual discernment would have been helpful to you?

discernment in spiritual direction

mystic soul in spiritual direction

The gift of the spiritual direction relationship is that we are granted insight into the sacred interiority of another person, and the mysterious way the Divine calls each of us to love. While practical matters of faith, prayer, and self-reflection arise in spiritual direction, the intent of the journey—enlightenment, union with God—is never lost.

A good spiritual guide will be sensitive to the tenderness of the person's journey and the process by which he or she is turning toward union and intimacy with God. In these encounters, it is helpful to recognize the signs of the mystic soul that is drawn into contemplation.

Signs of the Mystical Soul:

Every religion posits a Pure Consciousness or true Self, continually receptive to the transcendent. Thus, every person in essence has a mystic soul, united with its source. Every person experiences the oneness of the great cosmic-divine-human sphere. Every person is affected by violations to the universal love in which it is bathed in its deepest center. When a person is drawn into mystical consciousness, these latent capacities are specially activated and the soul—more open to contemplation—displays distinctive signs.

1. An increasingly intense desire for silence and solitude is present in the mystic soul. It is food, nourishment for the whole person, and not an escape from everyday life.

2. Dissatisfaction with prior ways of being, practice, and faith are often present, which can generate confusion, despair, and anguish.

3. The boundary between the higher and lower consciousness and the inner and outer life is translucent, permeable. A person experiencing this flows between natural and supernatural states of consciousness and is innately open to the Divine within.

4. The personality is often very pliable and receptive, and therefore finds it difficult and often doesn't know how to establish boundaries in personal and social relationships.

5. The effects of the material world—in its positive and negative aspects, emotions, and experiences—reverberate more intensely and more immediately. There is, thus, an unusual depth of sensitivity to the intuitive and emotive, as well as to harshness and cruelty.

6. The anguish of people and creation pierces the heart and elicits a desire to heal and bring comfort. This mystical solidarity with another's suffering can be confused with one's own and/or with Divine suffering.

7. The thrust of daily life is in service of truth, inner transformation, and a desire to be more compassionate and loving. To paraphrase Sufi wisdom: In such a soul, the mirror of awareness is highly polished, reflecting more purely and more intensely Divine Light.

mystic soul in spiritual direction

In what ways are you drawn into silence and solitude?

How do these moments of aloneness affect you?

Are you aware of how your soul reacts to violations of love in personal relations and/or in relation to society and the natural world?

Does the notion of a permeable, translucent boundary between natural and supernatural consciousness resonate in your experience?

Practice the following:

- Before a scheduled meeting, when you are seeing patients, speaking with your family, or guiding members of your congregation, take a few moments of meditative silence to center yourself and to ask for spiritual clarity.

- Maintain a quiet presence, being attentively aware of what the other person is saying and the state of her or his mind and heart.

- Listen with your whole being, and from the ear of your heart.

- Allow the other person to speak from the heart by maintaining a receptive and open demeanor and by not interrupting, judging, or challenging his or her words.

- Encourage further openness by asking for clarification or raising questions that allow the person to more deeply reflect on her or his concerns.

- Remain aware of your own feelings and responses as you practice quiet, attentive listening.

- When the dialogue is over, take a few moments of silence, and then review and write down any immediate responses or feelings.

Practice being a spiritual director in your professional life.

In your chosen profession—as a physician, clergy, nurse, counselor, educator, business professional, and so forth—apply the listening skills of spiritual directors to your work.

practice being a spiritual director

JOURNAL

being a spiritual director

Were you able to listen with your whole being, with the ear of the heart, waiting in silence to respond? How did it feel to listen in this way?

Where did you find the greatest sense of connection or peace with listening in this way?

Did it help you to better evaluate or understand the person who was speaking?

Was there anything about this form of listening that you found to be difficult or uncomfortable? Reflect on this part of the experience.

conclusion

Spiritual direction is a gift of the spirit that leads those who practice it to an encounter with the sacred dimension of life. It is a ministry that provides access to the inner dimension of the person and teaches us how to grow in compassion and love. Through the centuries, spiritual companionship has brought together people from all cultures and religious traditions to listen to and learn from the heart. It is this attunement to the deepest center of the person and to the Spirit animating us from within that is the primary focus of spiritual direction, a focus vitally important to the sustenance of our bodies, minds, and souls.

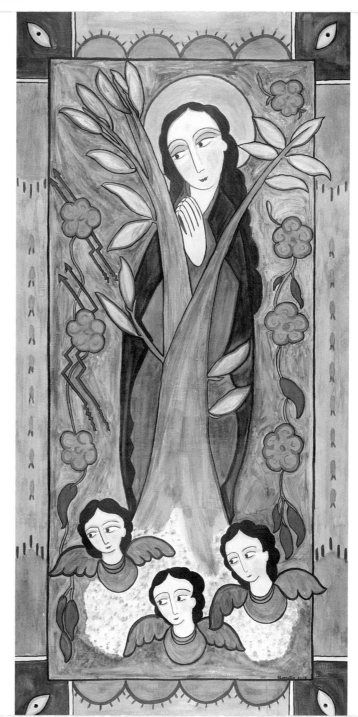

Reflect on and write about what you have learned about spiritual direction. Be specific as you review your learning experience, focusing on what was most important to you in terms of your spiritual understanding and growth, and whether you find yourself drawn to pursuing a spiritual direction ministry. Feel free to write as much as you like and to explore areas that are particular to your life circumstances.

Reading List

Addison, Howard. *Show Me Your Way: The Complete Guide to Exploring Interfaith Spiritual Direction.* Woodstock, VT: Skylight Paths Publishing, 2000.

Allen, Joseph J. *Inner Way: Toward a Rebirth of Eastern Christian Spiritual Direction.* Grand Rapids, MI: William B. Eerdmans, 1994.

Barry, William and William J. Connelly. *The Practice of Spiritual Direction.* San Francisco: Harper, 1952.

Billy, Dennis. *With Open Heart: Spiritual Direction in the Alphonsian Tradition.* Liguori, MO: Liguori Press, 1989.

Burckhardt, Titus, trans. *Letters of a Sufi Master: The Shaykh ad-Darqawi.* Louiseville, KY: Fons Vitae, 1998.

Byrne, Lavinia, ed. *Traditions of Spiritual Guidance.* Collegeville, MN: Liturgical Press, 1990.

Casey, Michael. *Sacred Reading: The Ancient Art of Lectio Divina.* Liguori, MO: Liguori Publications, 1996.

Conroy, Maureen R.S.M. *The Discerning Heart: Discovering a Personal God.* Chicago: Loyola Press, 1993.

Conroy, Maureen. *Looking Into the Well: Supervision of Spiritual Directors.* Chicago: Loyola University Press, 1995.

Dougherty, Mary Rose. *Group Spiritual Direction: Community for Discernment.* New York: Paulist Press, 1995.

Dyckman, Katherine Marie and L. Patrick Carroll. *Inviting the Mystic, Supporting the Prophet: An Introduction to Spiritual Direction.* New York: Paulist Press, 1981.

Edwards, Tilden. *Spiritual Director, Spiritual Companion: Guide to Tending the Soul.* New York: Paulist Press, 2001.

Empereur, James L. *Spiritual Direction and the Gay Person.* New York: Continuum, 2002.

Fischer, Kathleen. *Women at the Well: Feminist Perspectives on Spiritual Direction.* New York: Paulist Press, 1988.

Fortunato, John E. *Embracing the Exile: Healing Journeys of Gay Christians.* New York: The Seabury Press, 1983.

Gandhi, Mohandas K. *Prayer.* Berkeley, CA: Berkeley Hill Books, 2000.

Gratton, Carolyn. *The Art of Spiritual Guidance: A Contemporary Approach to Growing in the Spirit.* New York: Crossroad, 1992.

Hall, Thelma. *Too Deep for Words: Rediscovering Lectio Divina.* New York: Paulist Press, 1988.

Hart, Thomas N. *The Art of Christian Listening.* New York: Paulist Press, 1980.

Hart, Thomas. *Spiritual Quest: A Guide to the Changing Landscape.* New York: Paulist Press, 1999.

Houdek, Frank J., S.J. *Guided by the Spirit: A Jesuit Perspective on Spiritual Direction.* Chicago: Loyola Press, 1996.

Lanzetta, Beverly. *Emerging Heart: Global Spirituality and the Sacred.* Minneapolis: Fortress Press, 2007.

Lanzetta, Beverly. *Radical Wisdom: A Feminist Mystical Theology.* Minneapolis: Fortress Press, 2005.

Lanzetta, Beverly. *The Monk Within: Embracing a Sacred Way of Life.* Sebastopol, CA: Blue Sapphire Books, 2018.

Theology. Minneapolis: Fortress Press, 2005.

Larkin, Ernest O.Carm. *Silent Presence: Discernment as Process and Problem.* New Jersey: Dimension Books, 1981.

Mabry, John R. *Noticing the Divine: An Introduction to Interfaith Spiritual Guidance.* Harrisburg, NY: Morehouse Publishing, 2006.

May, Gerald G. *The Dark Night of the Soul: A Psychiatrist Explores the Connection Between Darkness and Spiritual Growth.* San Francisco: HarperSanFrancisco, 2005.

Reading List *continued*

McGreal, Wilfred. *At the Fountain of Elijah: The Carmelite Tradition.* New York: Orbis Books, 1999.

Merton, Thomas. *Spiritual Direction & Meditation.* Collegeville: MN: The Liturgical Press, 1960.

Merton, Thomas, trans. *The Wisdom of the Desert: Sayings from the Desert Fathers of the Fourth Century.* New York: New Directions, 1970.

Milgram, Rabbi Goldie and Rabbi Shohama Wiener, eds. *Seeking and Soaring: Jewish Approaches to Spiritual Guidance and Development.* New Rochelle, NY: Reclaiming Judaism Press, 2015.

Nemeck, Francis Kelly, and Marie Theresa Coombs. *O Blessed Night: Recovering from Addiction, Codependency and Attachment Based on the Insights of St. John of the Cross and Pierre Teilhard de Chardin.* New York: Alba House, 1991.

Nemeck, Francis Kelly and Marie Theresa Coombs. *The Way of Spiritual Direction.* Collegeville, MN: The Liturgical Press, 1985.

Neufelder, Jerome M., and Mary C. Coelho, eds. *Writings on Spiritual Direction By Great Christian Masters.* Greenwich, CT: The Seabury Press, 1982.

Nouwen, Henri J.M. *Discernment: Reading the Signs of Daily Life.* New York: HarperOne, 2015.

Nouwen, Henri J.M. *Spiritual Direction: Wisdom for the Long Walk of Faith.* New York: HarperOne, 2015.

Ochs, Carol and Kerry Olitzky. *Jewish Spiritual Guidance: Finding Our Way to God.* New York: Jossey-Bass, 1997. O'Neill, Craig and Kathleen Ritter. Coming Out Within: Stages of Spiritual Awakening for Lesbians and Gay Men. San Francisco: HarperSanFrancisco, 1992.

Palmer, G.E.H., Philip Sherrard, and Kallistos Ware, eds. *Philokalia, vols. 1–5.* Boston: Farber & Faber, 1979.

Ranft, Patricia. *A Woman's Way : The Forgotten History of Women Spiritual Directors.* New York: Palgrave Macmillan, 2001.

Rakoczy, Susan ed. *Common Journey, Different Paths: Spiritual Direction in Cross-Cultural Perspective.* Maryknoll, NY: Orbis Books, 1992.

Ruffing, Janet. *Spiritual Direction: Beyond the Beginnings.* New York: Paulist Press, 2000.

Russell, Norman, and Benedicta Ward, trans. *The Lives of the Desert Fathers.* London: Mowbray and Kalamazoo, MI: Cistercian Publications, 1980.

Schachter-Shalomi, Zalman. *Spiritual Intimacy: A Study of Counseling in Hasidism.* Northvale, NJ: Jason Aronson, 1996.

Swan, Laura. *The Forgotten Desert Mothers: Sayings, Lives, and Stories of Early Christian Women.* New York: Paulist Press, 2001.

Underhill, Evelyn. *Practical Mysticism.* New York: Dover Publications, 2000.

Vest, Norene, ed. *Tending the Holy: Spiritual Direction Across Traditions.* New York: Morehouse Publishings, 2003.

Waddell, Helen, trans. *The Desert Fathers.* New York: Vintage Books, 1998.

Ward, Benedicta, trans. *The Desert Fathers: Sayings of the Early Christian Monks.* New York: Penguin Classics, 2003.

Ward, Benedicta, trans. *The Sayings of the Desert Fathers. The Alphabetical Collection.* London/Oxford: Mowbray, 1981.

Ware, Kallistos. *The Inner Kingdom.* Crestwood, NY: St. Vladimir's Seminary Press, 2001.

Welch, John O.Carm. *The Carmelite Way: An Ancient Path for Today's Pilgrim.* New York: Paulist Press, 1996.

Wilson, H.S., Judo Poerwowidagdo, Takatso Mofokeng, Robert Evans and Alice Evans. *Pastoral Theology from a Global Perspective: A Case Method Approach.* New York: Orbis Books, 1996.

Wolff, Pierre. *Discernment: The Art of Choosing Well.* Liguori, MO: Liguori Press, 1993.

Art Credits

Page

Cover, Beverly Lanzetta, *Our Lady of Refuge*, 2008.

1. Nicholas Roerich, *Bridge of Glory*, 1923.
2. Beverly Lanzetta, *Blue Guadelupe*, 2005.
3. Nicholas Roerich, *Burning of Darkness*, 1924. Fragment
4. Nicholas Roerich, Album leaf, 1930s. Fragment
5. Beverly Lanzetta, *Angel Isabel*, 2004. Fragment
6. Beverly Lanzetta, *Pace e Bene*, 2006. Fragment
7. Beverly Lanzetta, *Illumination of Rabi'a*, 2004.
8. Nicholas Roerich, *Milarepa, the One Who Harkened*, 1925. Fragment.
10. Nicholas Roerich, *Pilgrim of the Radiant City*, 1933. Fragment
11. Beverly Lanzetta, *Red Guadalupe*, 2003.
13. Nicholas Roerich, *Krishna*, 1929. Fragment
14. Nicholas Roerich, *Mother of the World*, 1924.
15. Nicholas Roerich, *Star of the Hero*, 1936.
18. Beverly Lanzetta, *Indwelling of Shekhinah*, 2005.
20. Beverly Lanzetta, *Julian of Norwich*, 2004.
25. Beverly Lanzetta, *Julian of Norwich*, 2004.
27. Beverly Lanzetta, *Our Lady of Light*, 2006.
28. Beverly Lanzetta, *Red Guadalupe*, 2003.
30. Nicholas Roerich, *Drops of Life*, 1924. Fragment
41. Beverly Lanzetta, *Stella Maris*, 2008. Fragment
43. Nicholas Roerich, *Gundla*, 1931. Fragment

47. Beverly Lanzetta, *Our Lady of Refuge*, 2008.
48. Beverly Lanzetta, *Mother of Light*, 2008.
57. Beverly Lanzetta, *Teresa of Avilia*, 2003.
59. Nicholas Roerich, *From Beyond*, 1936. Fragment
60. Beverly Lanzetta, *Joy*, 2019.
59. Beverly Lanzetta, *Teresa of Avila*, 2003. Fragment
59. Beverly Lanzetta, *Teresa of Avila*, 2003.
63. Nicholas Roerich, *Mount of Five Treasures*, 1933. Fragment
73. Nicholas Roerich, *Kuan-Yin*, 1933. Fragment
74. Beverly Lanzetta, *Hildegard of Bingen*, 2005.
77. Nicholas Roerich, *Command of Rigden Djapo*, 1933. Fragment
78. Beverly Lanzetta, *Meister Eckhart*, 2008.
80. Nicholas Roerich, *Krishna*, 1929. Fragment
83. Beverly Lanzetta, *John of the Cross*, 2008.
84. Nicholas Roerich, *Remember*, 1924.
87. Beverly Lanzetta, *St. Ignatius of Loyola*, 2008.
88. Nicholas Roerich, *From Beyond*, 1936. Fragment
84. Beverly Lanzetta, *Bodhisattava of Compassion*, 2005.
93. Beverly Lanzetta, *Joy*, 2019.
95. Beverly Lanzetta, *Bodhisattava of Compassion*, 2005.
97. Beverly Lanzetta, *Mother of Joy*, 2008.

The Monk Within Series focuses on the inner wisdom that has sustained countless individuals and cultures throughout history. Designed to provide the contemplative atmosphere of the monastic setting in a modern, interfaith context, the series is modeled on an ancient ideal of soul-to-soul learning. By bringing together the best of contemporary scholarship with contemplative study and practice, our books strive to integrate the rich insights of modern life with the intense, interior work that generates personal and communal transformation.

Books by Beverly Lanzetta in the *Monk Within Series:*

The Monk Within:
Embracing a Sacred Way of Life
ISBN: 9780984061655

Foundations in Spiritual Direction:
Sharing the Sacred Across Traditions
ISBN: 9781732343818

A New Silence:
Spiritual Practice and Formation for the Monk Within
forthcoming 2020

A Feast of Prayers:
Daily Devotions to Holy Mystery
forthcoming 2020

CPSIA information can be obtained at www.ICGtesting.com
Printed in the USA
BVIW120125021019
559807BV00013BA/250